THE HAMPTONS SUITE

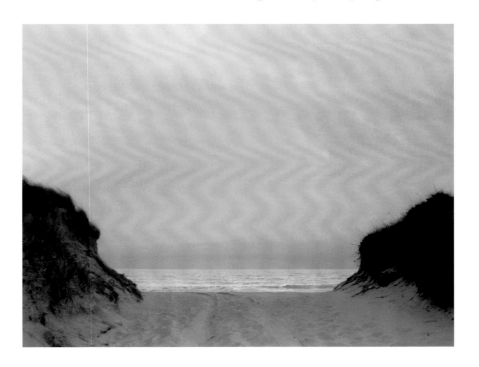

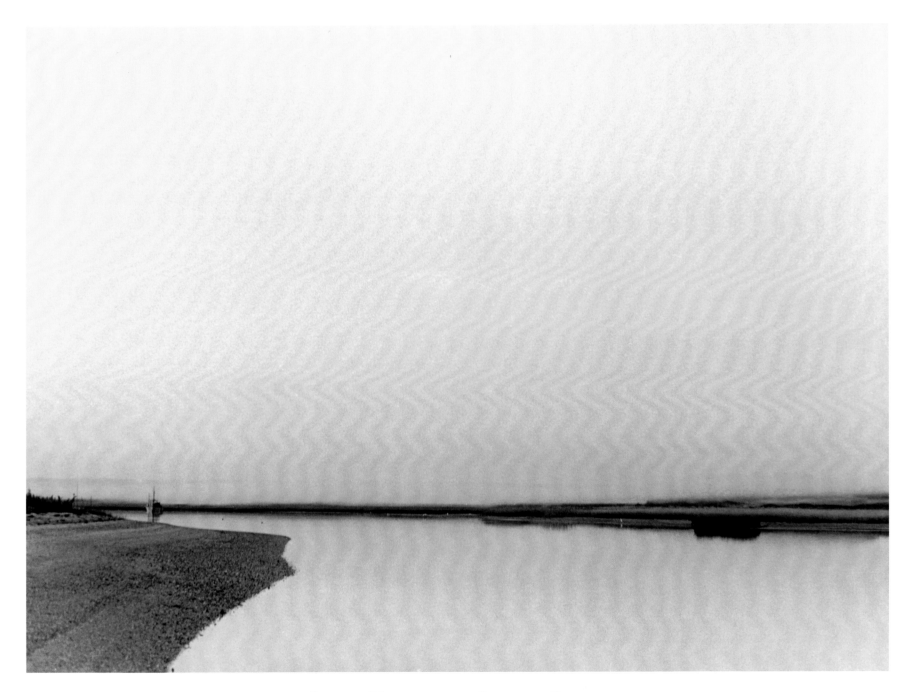

STILL MORNING, LOUSE POINT

THE HAMPTONS SUITE

PHOTOGRAPHS BY
KEN ROBBINS

INTRODUCTION BY ANTHONY BRANDT

ACCABONAC BOOKS
EAST HAMPTON NEW YORK
2000

For Maria

ISBN 0-9678516-0-2

Library of Congress Card Number: 00-100244

Designed by Ken Robbins & Kathleen Westray
Printed by Penmor Lithographers, Lewiston, Maine

Acknowledgements
The author wishes to thank
Hal Zwick, Phillip Spitzer, Genie Henderson, Annelise Spitzer,
Rob Schumann Tony Brandt, Kathleen Westray, Pam Williams,
and Arnie and Liz of the Lizan-Tops Gallery—
each of whom (among others) has encouraged,
enabled, or contributed to this book

Accabonac Books
921 Fireplace Road,
East Hampton, New York, 11937
pub@accabonacbooks.com

THE FIRST TIME my brother came to visit me in the Hamptons some twelve or thirteen years ago I drove him to Sagaponack past the cemetery there and down Daniel's Lane, which runs parallel to the beach, and he was amazed. "The potato fields run right up to the back of the dunes!" he exclaimed. It was one of the first things I had noticed, too, when I moved out here. Where real estate development has yet to overtake them the farm fields and the beaches do indeed lie adjacent. Freshwater ponds open directly onto the sea. Houses dating to the eighteenth century still stand in the villages. My brother and I had been raised on the Jersey Shore on a barrier island. When I came here I wasn't used to all this, I had never seen it before, farms and beaches so close together, such quiet old resorts, the handsome old houses, or the light, above all the light, so soft yet so deep. The Jersey Shore was on the way even in my childhood to becoming a Queens with sand dunes and even then the sand dunes were vanishing, torn down so that the garish new houses behind them would have rooms with a view, while the marshes on the bay side were being filled in so that still more garish new houses could be built. All of them on sand. And the light on the Jersey Shore glares. It is a hard light; the ocean and the bay so close together bounce it around and intensify it, trees don't grow in the sand, there's no shade, no shelter, everything is naked, raw.

Not here. Here is special. Here a vast filter seems to hang above us and it washes and softens the light and liquifies it so that the air seems to swim in light, so that the two, air and light, seem to be adrift in each other and there are no hard edges anywhere. Here the soil is so rich, so right that it is ranked among the best in the world and the farmhouses have long since settled in, have become organic to the place. There are trees here hundreds of years old, and treeless moors, and a forest on the moraine of stunted oak and pine full of pheasants and foxes. To calm myself I walk sometimes to the end of the gentle curve of Havens Beach in Sag Harbor, past the last house, and look out over the empty marsh there and the creek that winds through it and often see the long slender neck and elegant head of a great blue heron rising above the creek banks. I have seen hawks cruising this marsh, and in the harbor itself in the winter red-breasted mergansers with their sharp bills, their rakish crests make their home on the waters. Farther out on the rocks there may be seals. Once on Long Beach I saw a sunset so glorious, with the undersides of the ribbed clouds, themselves a palette of soft grays, all streaked with pinks and roses and purple, that I could only stand there rooted and watch it fade and feel sentimental and foolish and grateful all at once, tears springing to my eyes.

Here the landscape is a kind of religion, just as full of silence and mystery, just as eloquent. Here the landscape feels like

some great gift and the light that lies upon it, a benediction. For well over a century it has attracted artists, from Thomas Moran, who brought his own private gondola from Venice and floated it on Hook Pond, to Fairfield Porter and beyond, all of them enchanted, mesmerized by the light, by the long flat horizontals, the muted colors, the peace. It is a pastoral landscape, not a dramatic, but do not be deceived. That is the North Atlantic out there, and it is as wild as oceans come. And don't call it scenery. It is a habitat, lived in by an extraordinary diversity of life; it boasts in fact one of the most diverse ecosystems anywhere. In 1994 the Nature Conservancy listed it as one of thirteen of the last great places in the world.

Which makes human beings only a small part of the whole. They come in armies but the foxes still thrive, stripers and blues still rule the surf, the raptors still rule the skies. Those of us who live here like the winters best. The people thin out, go back to the suburbs and the cities where the action is. Here the action is walking out to Cedar Point Light or watching the ice boats on those rare occasions when Sagg Pond or Mecox freeze up deeply enough for ice boats or taking your exercise on Gerard Drive, which borders Accabonac Harbor in Springs and may be on that score alone the most serene road in America. In winter the Hamptons are, indeed, a kind of well of serenity, from which you may drink at your pleasure. Drive in any direction and you will come to water and it will settle you down. Greater yellowlegs may be wandering in the shallows, with wintering buffleheads farther out. The place will quiet your mind. It is full of harbors, with all that that implies. It is a life's work if you are an artist. The liquidity of the light, the softness and depth of the colors are not easy things to transfer to two dimensions. The landscape generates painters but it is an illusion to think that painting it is simple. Its effects are elusive and transitory, the light changes like the tide, what was brilliant one day is pale the next. Fog is common here, and who can capture the fog?

Only, I suspect, Ken Robbins. Robbins is the most interesting and innovative photographer on the East End and photography is a peculiarly appropriate medium for this place. I became aware of his work in the early 1980s and was taken aback and somewhat put off by his methods at first. Robbins hand colors his photographs and I associated that with the excessively nostalgic work of Wallace Nutting in the 1910s and '20s, "pretty" scenes, lightly tinted, that succeeded only in being commercial. You can still find them in antique shops, at increasingly steep prices. It took me a while to see just how different Robbins' work was, how self-consciously aware of the history of art and how deeply meditated. That in fact is what photography does and why it works so well here, it seizes the evanescent, the moment, stops it and meditates upon it; it catches things in the midst of change, catches the light, waves, birds, the phases of the moon, the expressions on people's faces, and bears them into the realm of the eternal. Photography invites us into the still center of the turning world, suspends us for a breath in that juncture where time stops in place, where the wave is always just breaking, the trees are always just starting to emerge from the fog.

This moment is a moment of feeling and that is what Ken Robbins does and only an artist can do. He captures the

feeling: the feeling of this subtle watery landscape. We have seen the moments he depicts, starlings settling into a bare tree in the rain, the way people are scattered about a beach, a small sailboat lying at anchor. He gives them back to us, gives them back colored, in every sense of the word. He uses very finely ground colors that sink into the emulsion, they are always delicate and he uses them with restraint. They may not, to be sure, be the actual colors we saw, or even that exist. Like the blackbirds taking off in a swarm from a corn field: he has colored them pink and green and blue and brown and there are no such birds. But who has not known the momentary elation of seeing birds take off in an explosion of movement and isn't it a capital piece of wit to render that moment in the colors that belong to it, however black the birds—the colors we felt? Robbins is nothing if not witty, and he is also fully aware of the traditions in which he stands. Look at the photograph of four people standing on a beach so wrapped in haze you can barely see them and their tri-colored beach umbrella. What is this if not a glancing homage to William Merritt Chase, who specialized in scenes with beach umbrellas? Robbins makes photographs that look like Impressionist paintings, and others that have the still clarity of the American Luminist school. His pictures of single sculls on Accabonac Harbor are reminiscent of Thomas Eakins; lights across a harbor at dusk look just like Whistler's work. Still others could pass for colored postcards out of the 1920s and '30s. It is all deliberate, all meant. He uses digital cameras at times and manhandles the picture in the computer. He may paint the moon in when there was no moon. The sun sits just above the horizon, but the water below does not glitter, as the cliché demands, with its light. This is a sophisticated art that plays, that takes chances, and that quotes its forebears with sufficient bravado to invite comparison to them.

Yet it is local and connected at the same time. Above all it is an art of feeling and the feeling is for this place, this landscape, these old roads and the ponds they come to, the old graves and the old farms, the fog that drifts through the trees, the herons rising off the marshes, for the Sag Harbor Cinema, the beaches after a storm, for boats at rest and under sail, for the light that clothes it. No one I think has seen the East End better or more deeply or has loved it with his eyes quite so much. We gaze at the beauty of the natural world and long for oneness with it and oneness is always just out of reach. More than anything that's what Ken Robbins' photographs express, our longing, our sadness. Move too close and the heron will take off and fly to the end of our vision. Ken catches the moment of flight and its poignancy, its power. As sophisticated, witty and knowing as these pictures are, they are also much more, they reach us at a very deep level. They touch the unattainable. That is what the best art does, and this, undeniably, is some of the best. —A.B.

NOTE: Anthony Brandt is a free-lance writer who has lived for the past nineteen years in Sag Harbor. He has written for a number of national magazines and is currently the book columnist for National Geographic Adventure. He is married to Lorraine Dusky and has a dog named Jack.

AUTHOR'S NOTE

The photographs in this book represent over twenty-five years of picture taking and print making in the area where I have grown from young manhood to ripe middle age. It goes without saying that the land and I have changed a great deal, and not necessarily for the better, but the land remains one of the most beautiful in America (while I am no better looking than I've ever been). As for the photographs, it has never been my ambition to record without comment or interpretation — all of them were shot in black and white, and most were hand colored, either with pigment dyes, or (more recently) on the computer. These are adulterated views — feelings have been added.

—K. R.

December, 1999

THE PLATES

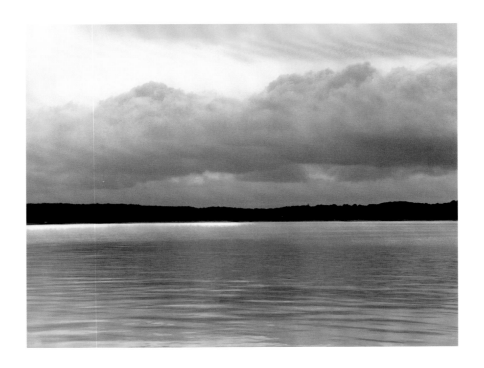

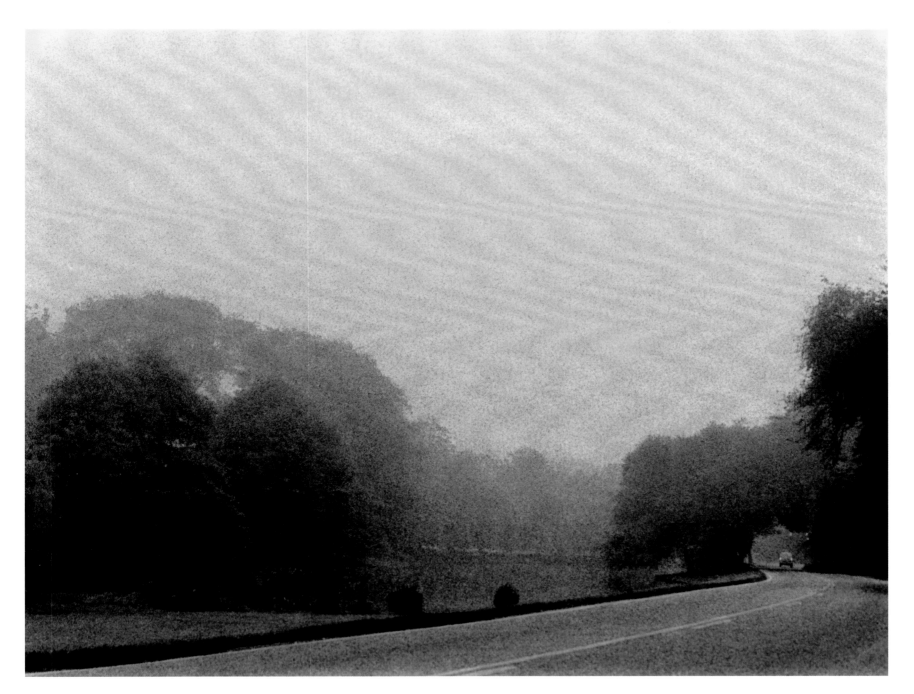

1. Town Pond and Main Street

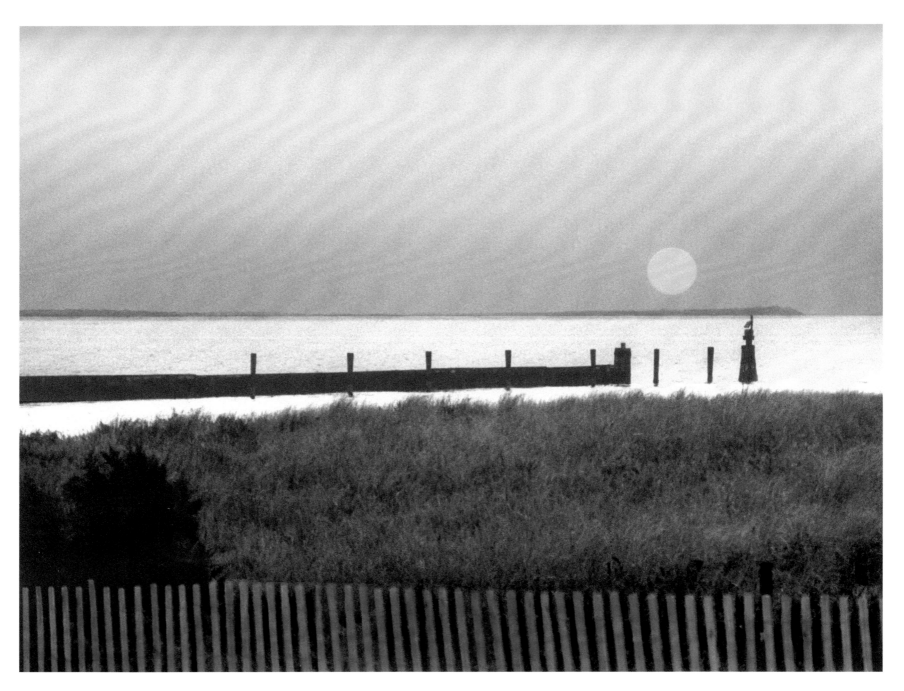

2 . THREE MILE HARBOR ENTRANCE

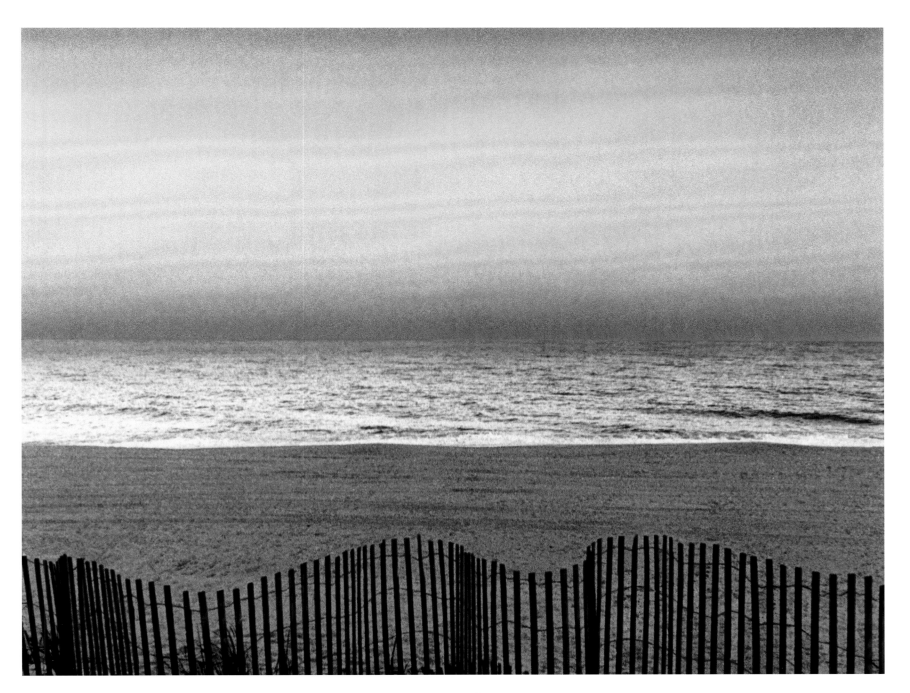

3. Littoral Abstract

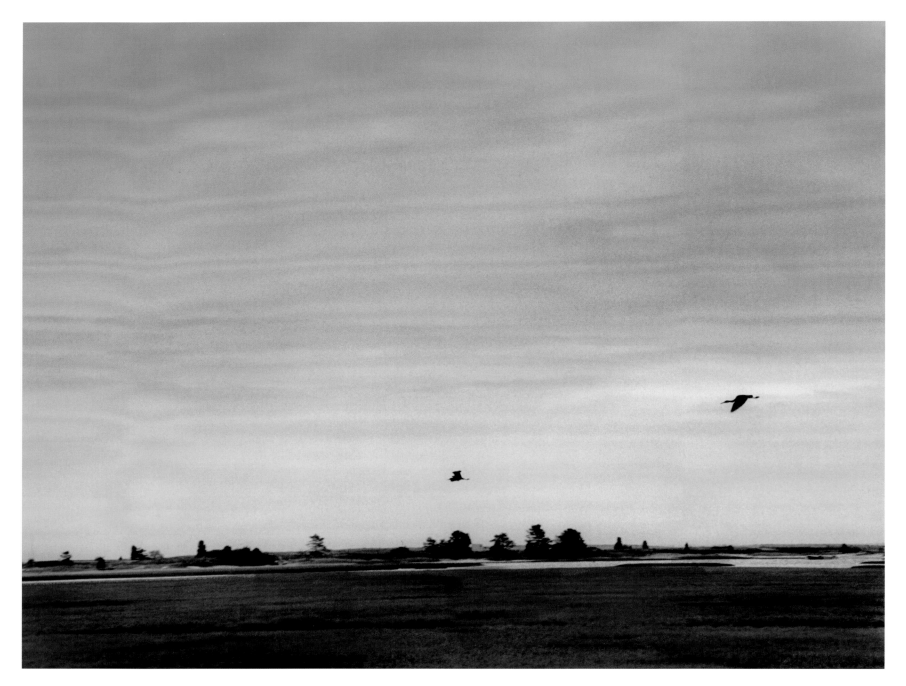

4. TWO HERONS

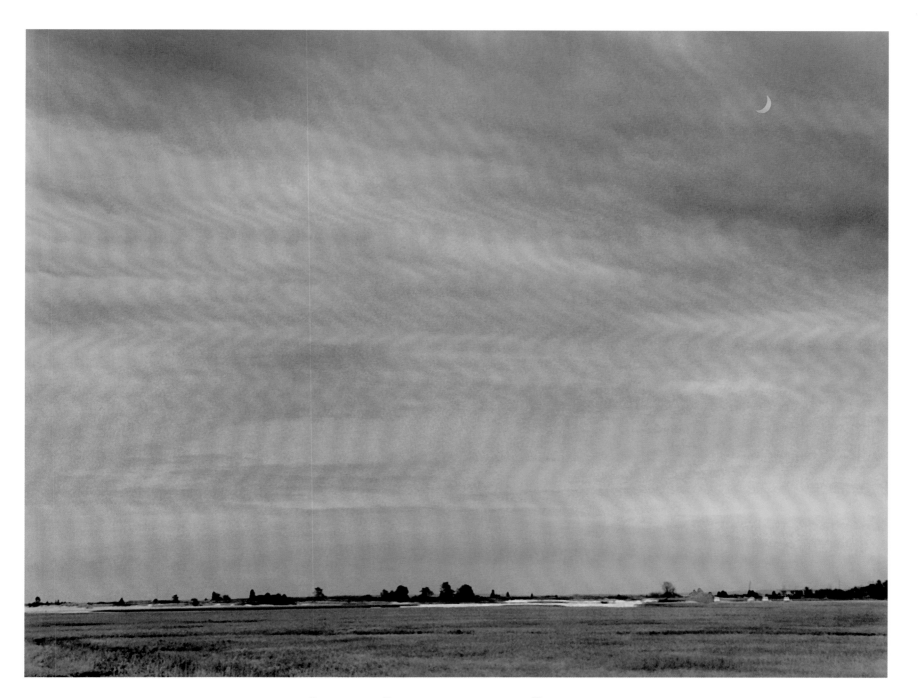

5. LOUSE POINT IN THE DISTANCE

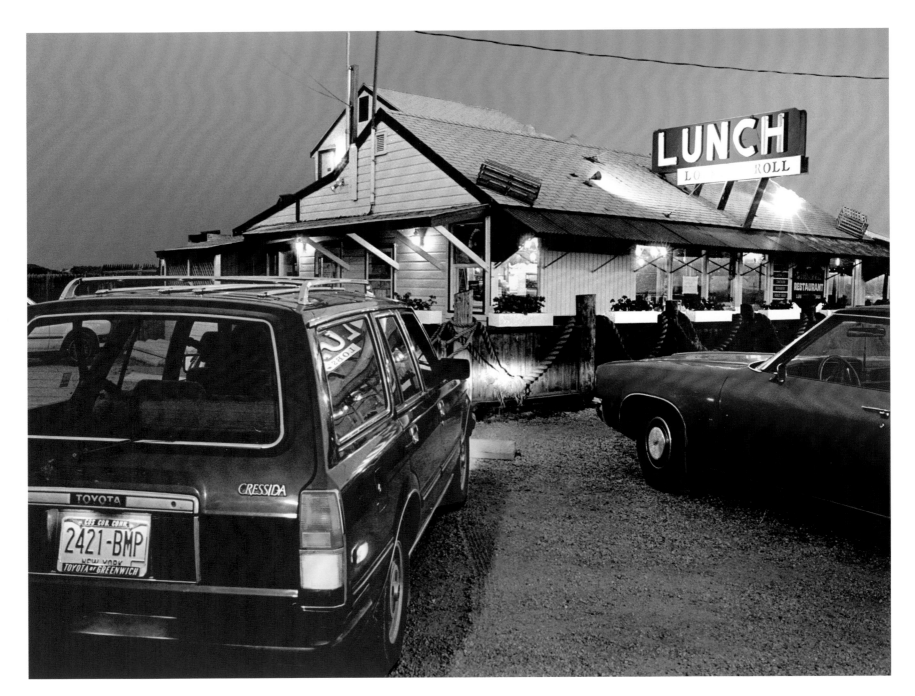

6. Lunch

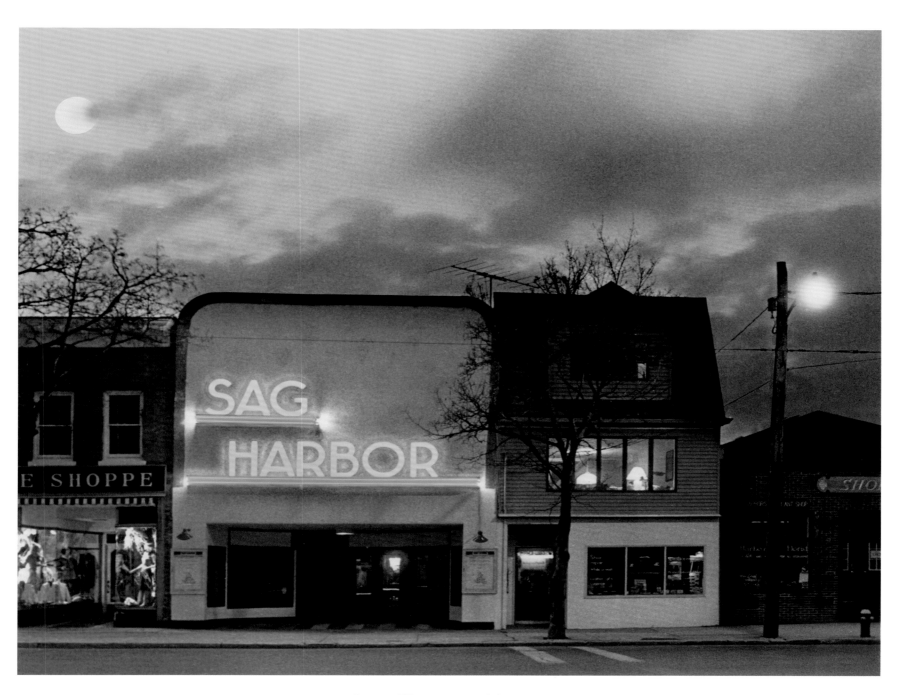

7. Sag Harbor Theater

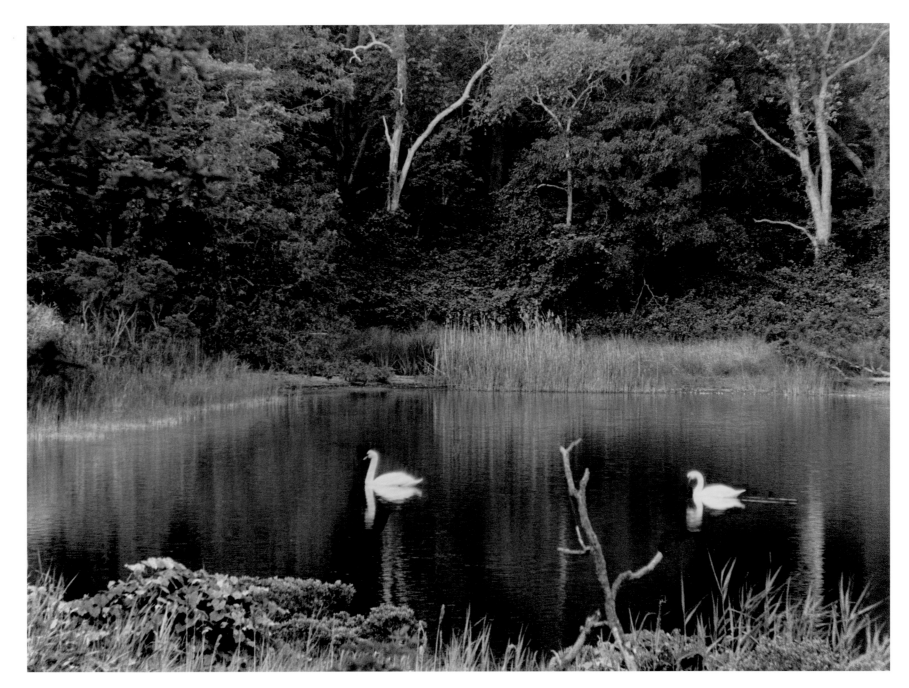

8. Swans, Gardiners Island

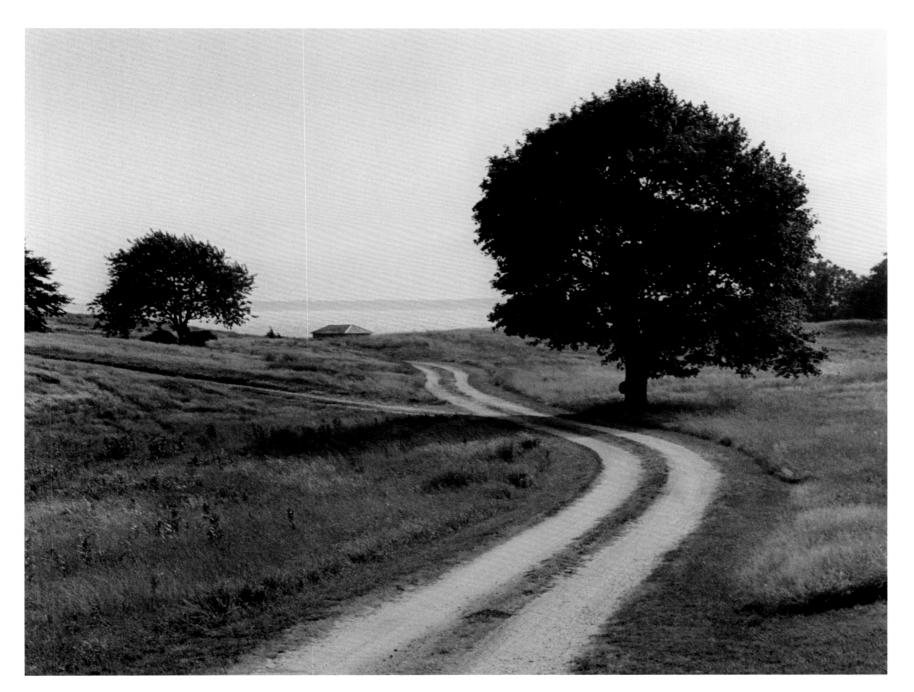

9. GARDINERS ISLAND PATH

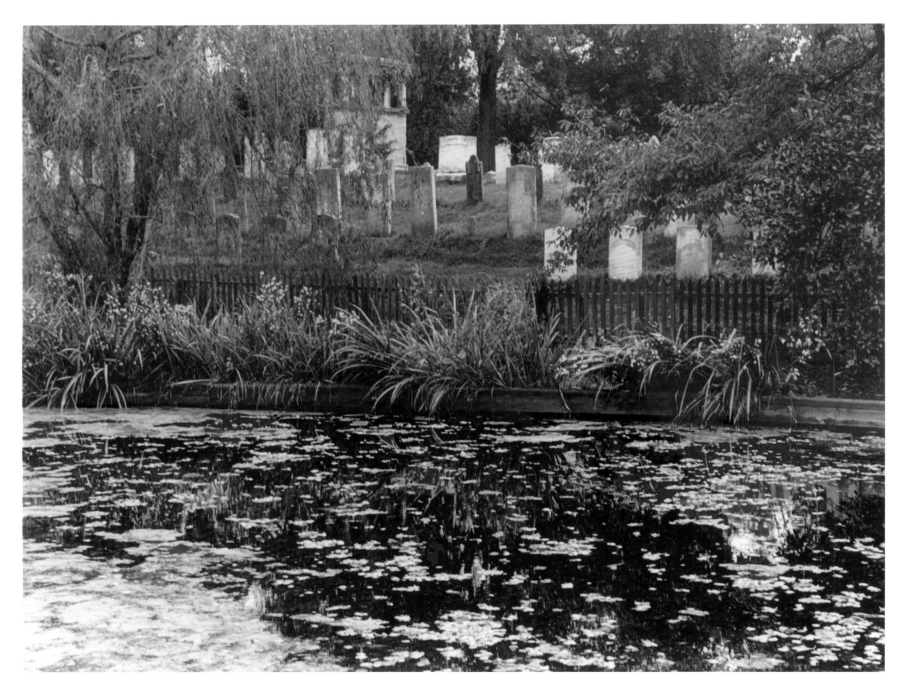

10. TOWN POND AND CEMETERY

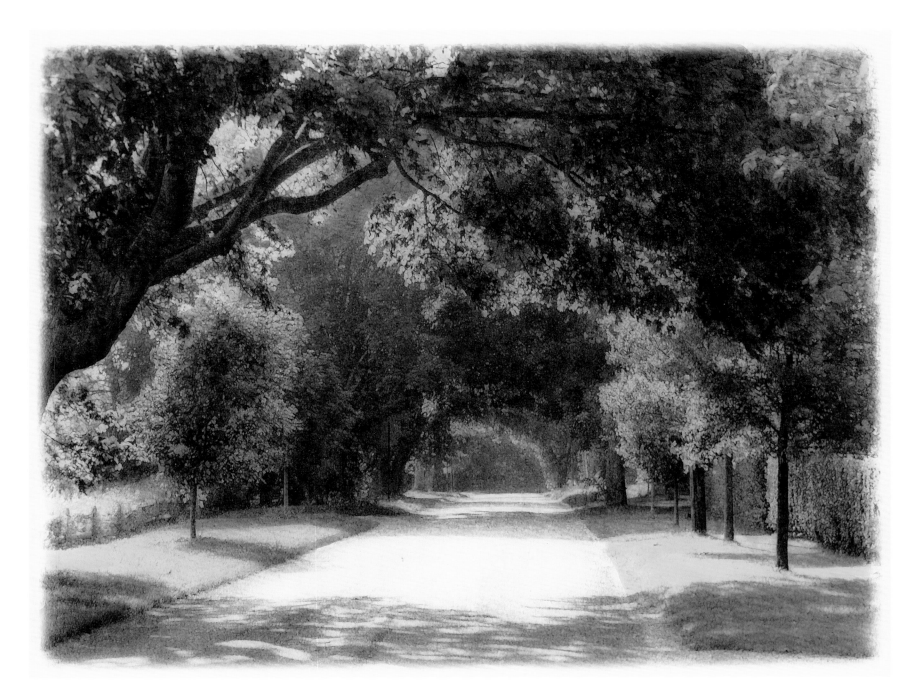

11. Shady Lane

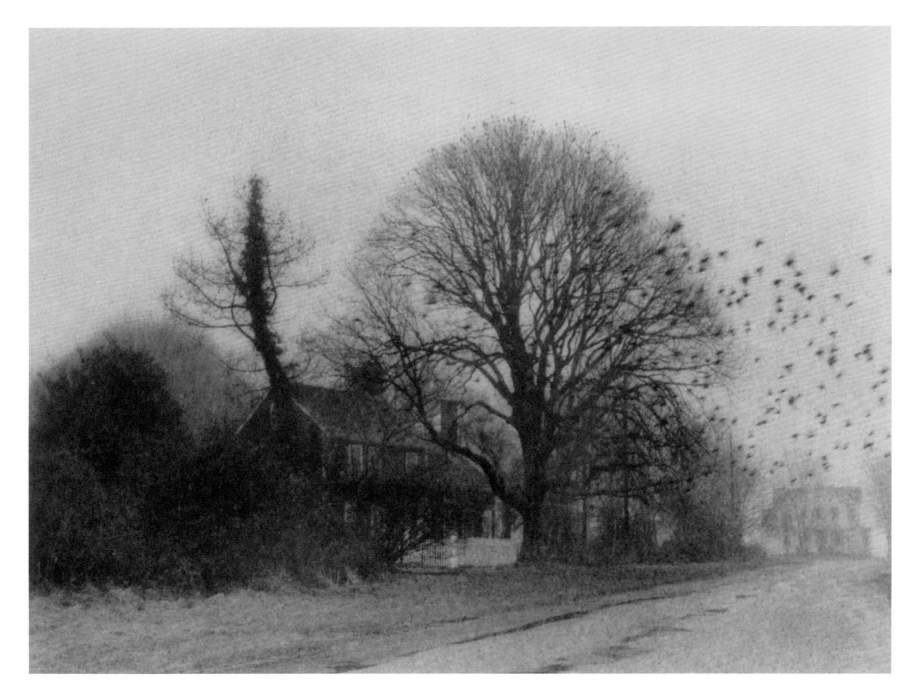

12. BLACKBIRDS IN THE RAIN, PARSONAGE LANE

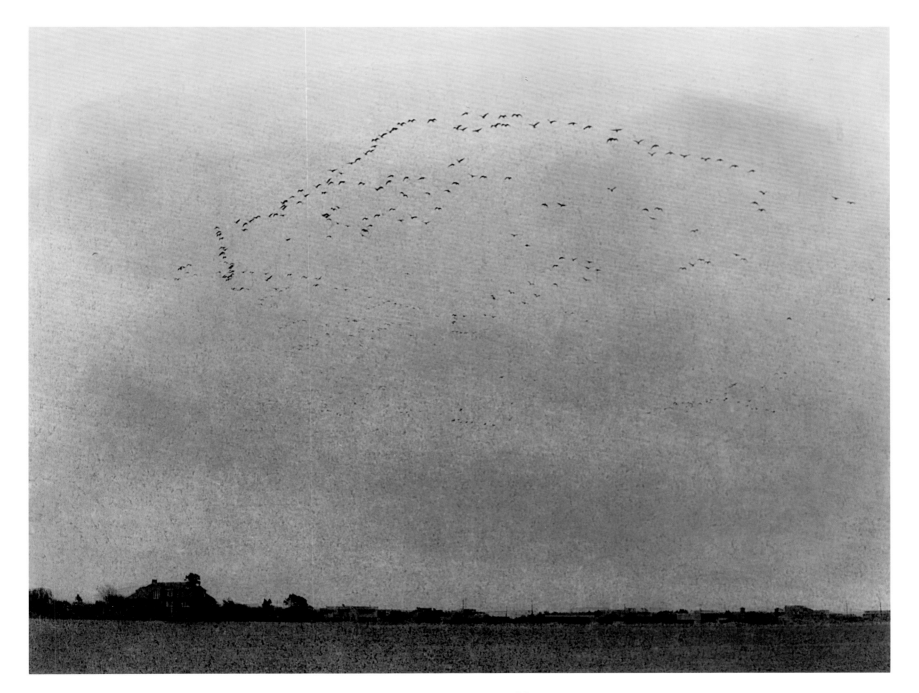

13. FORMING UP

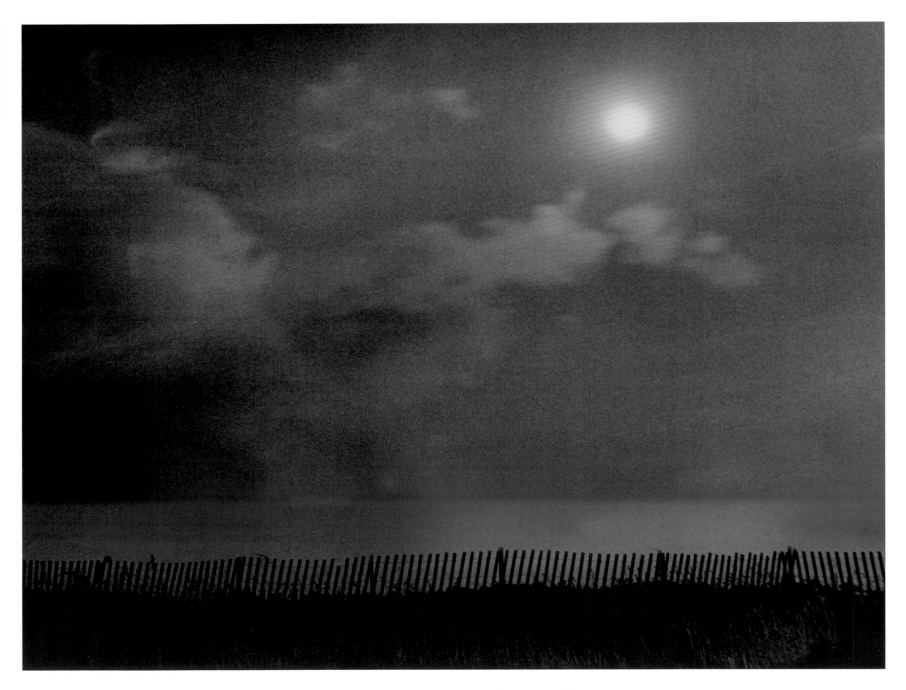

14. MOONLIGHT AND DUNE FENCE

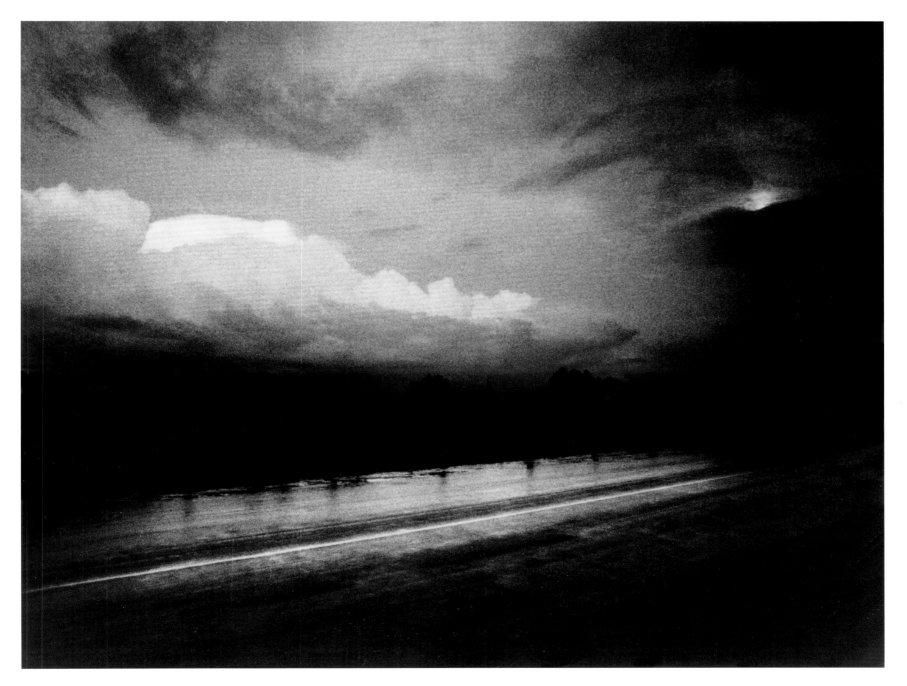

15. NOCTURNE

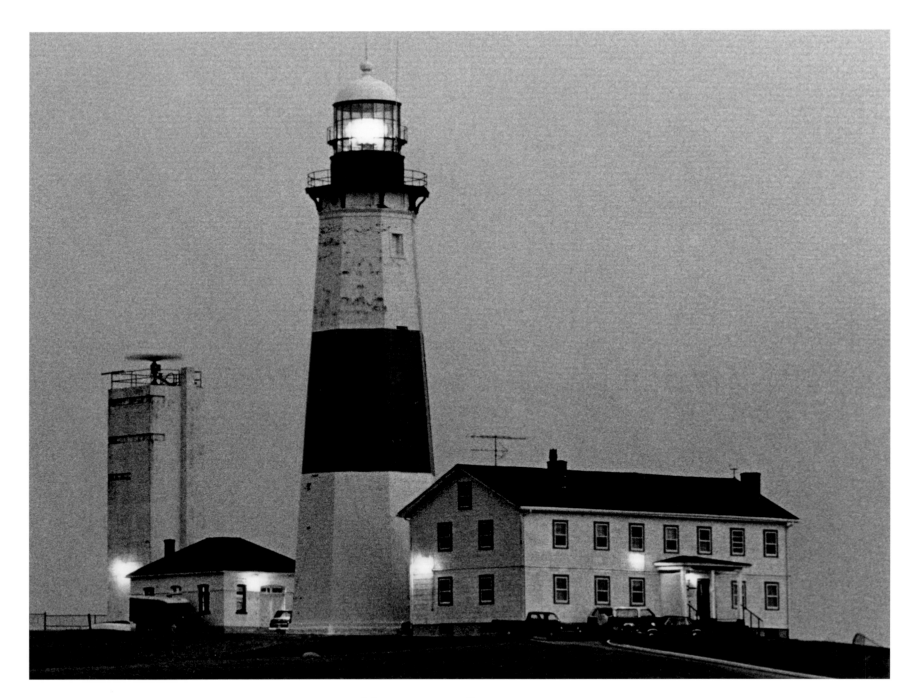

16. Montauk Lighthouse

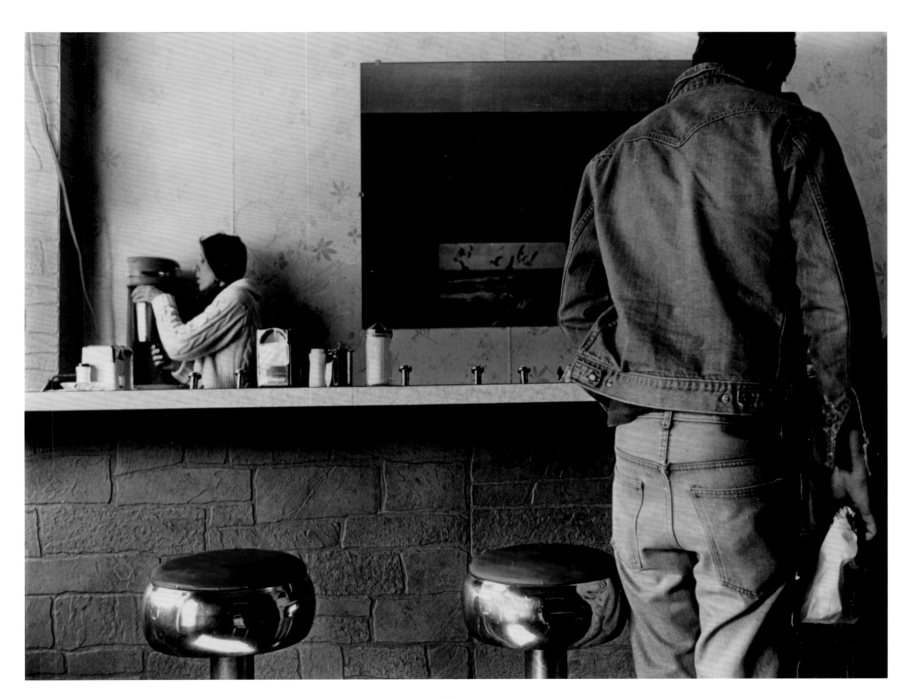

17. Eddie's Luncheonette

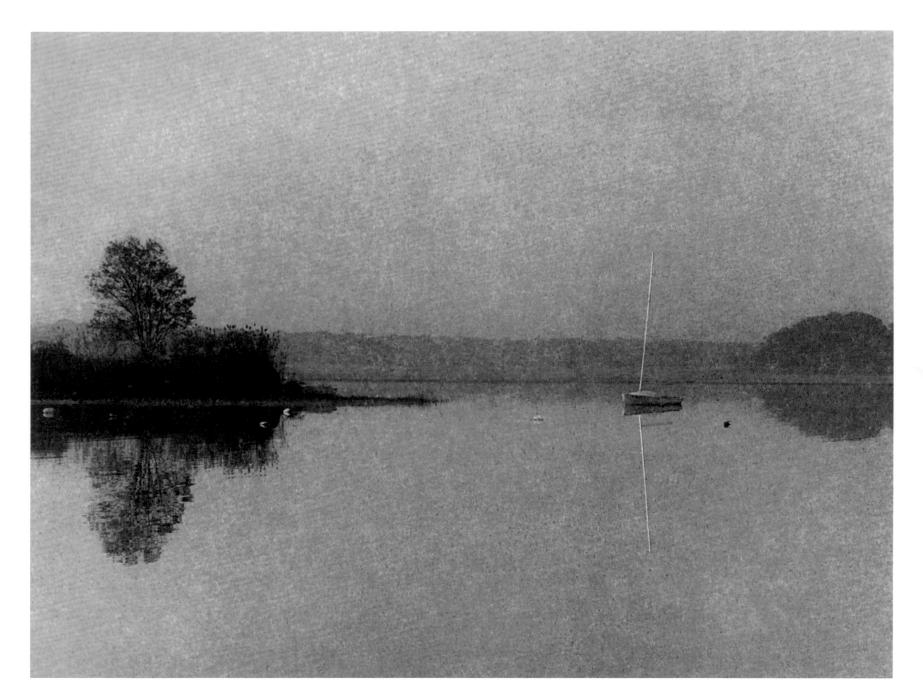

18. Boat at Mooring, Accabonac

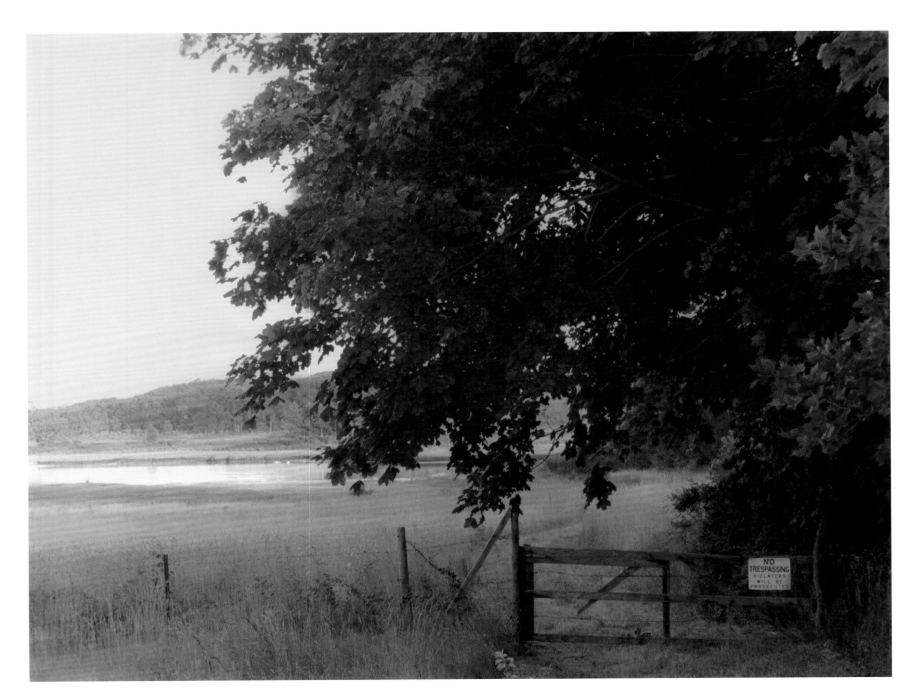

19. No Trespassing

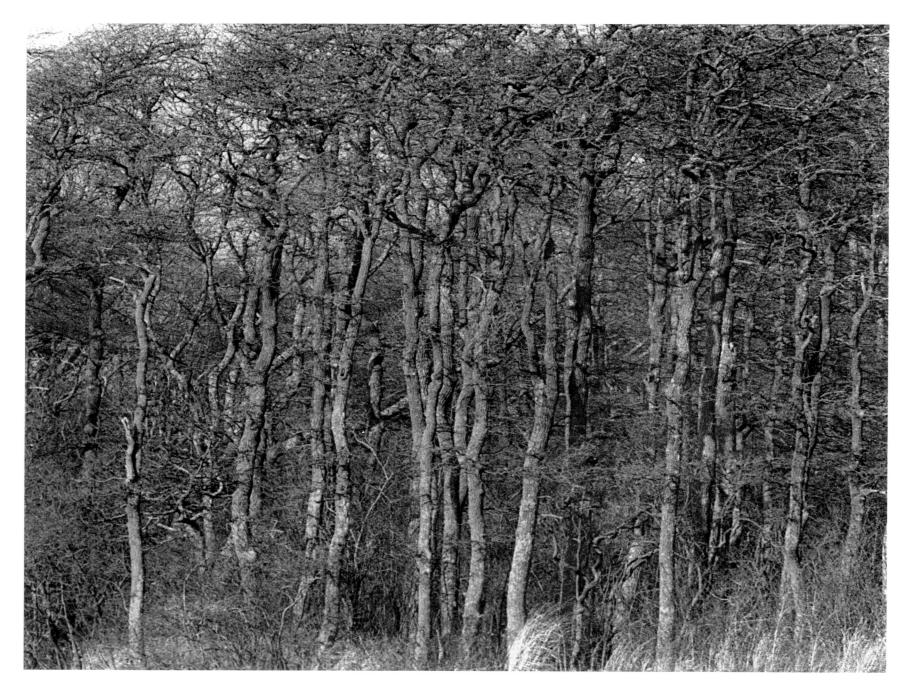

20. GEORGICA WOODS

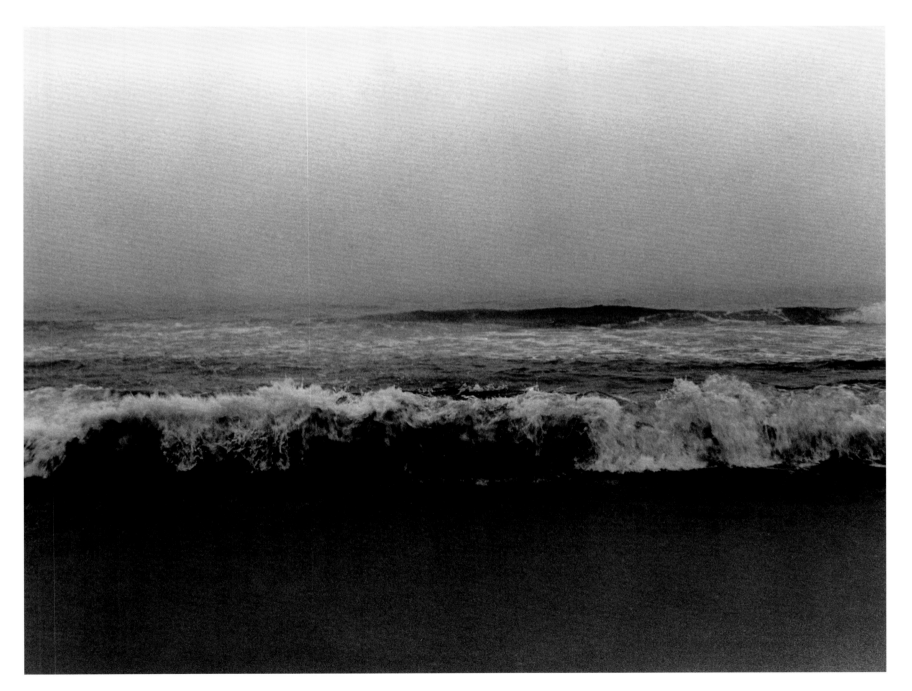

21. Napeague Surf

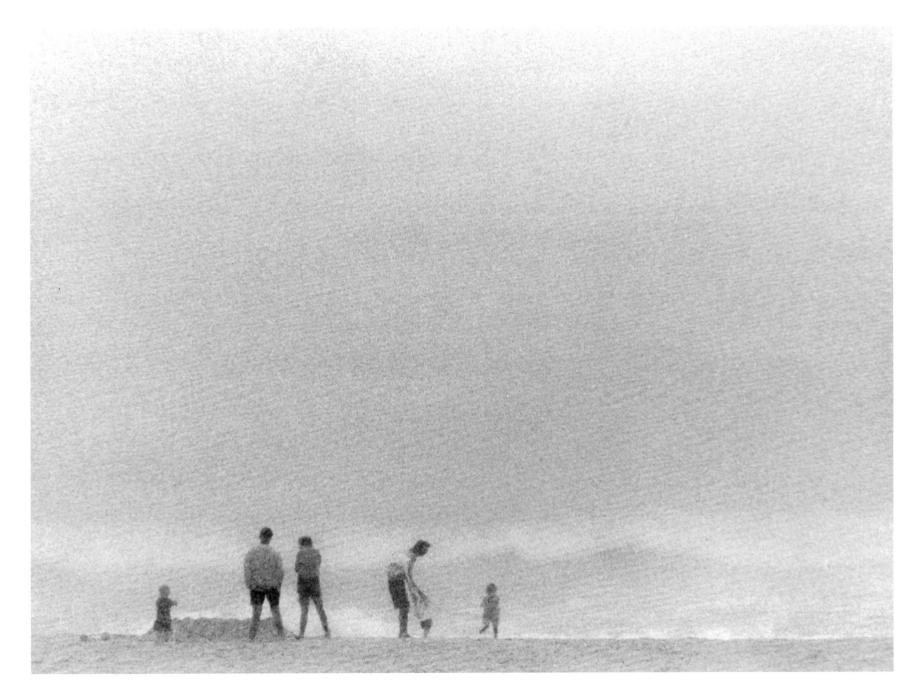

22. Foggy Beach

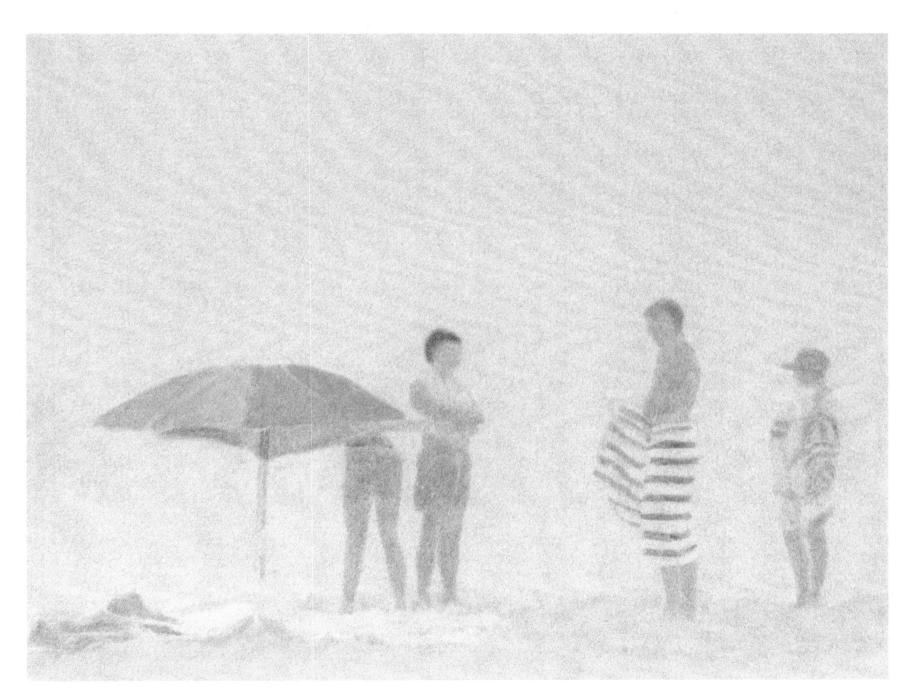

23. THE STRIPED TOWEL

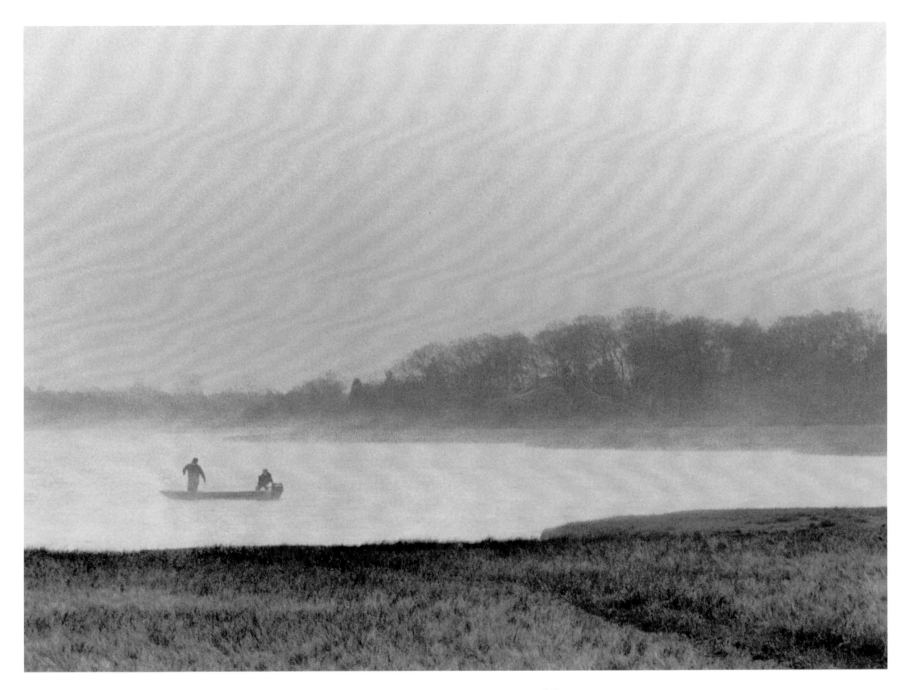

24. BOATMEN IN THE MIST

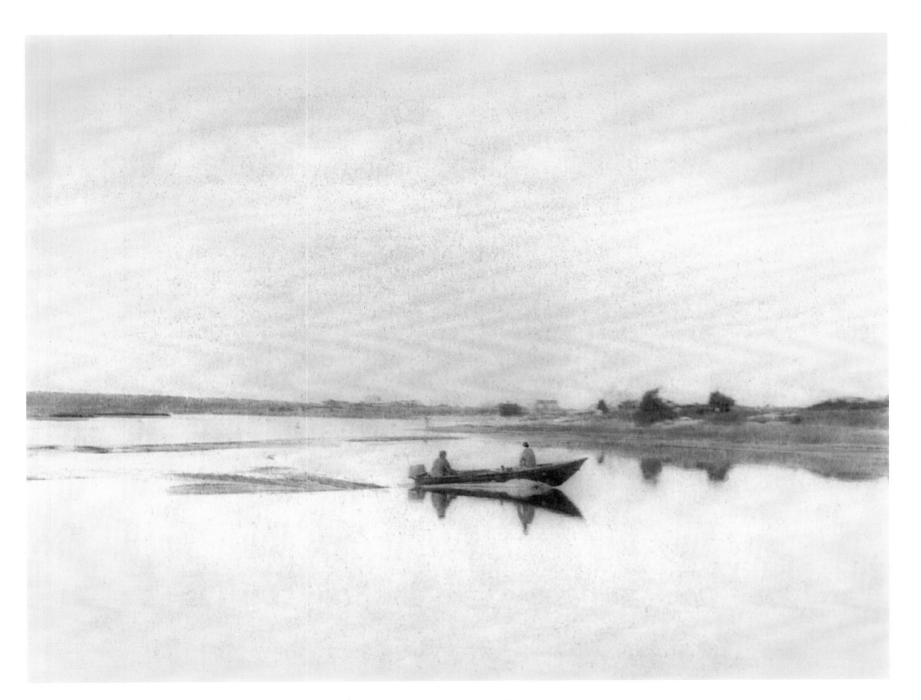

25. ACCABONAC BAYMEN

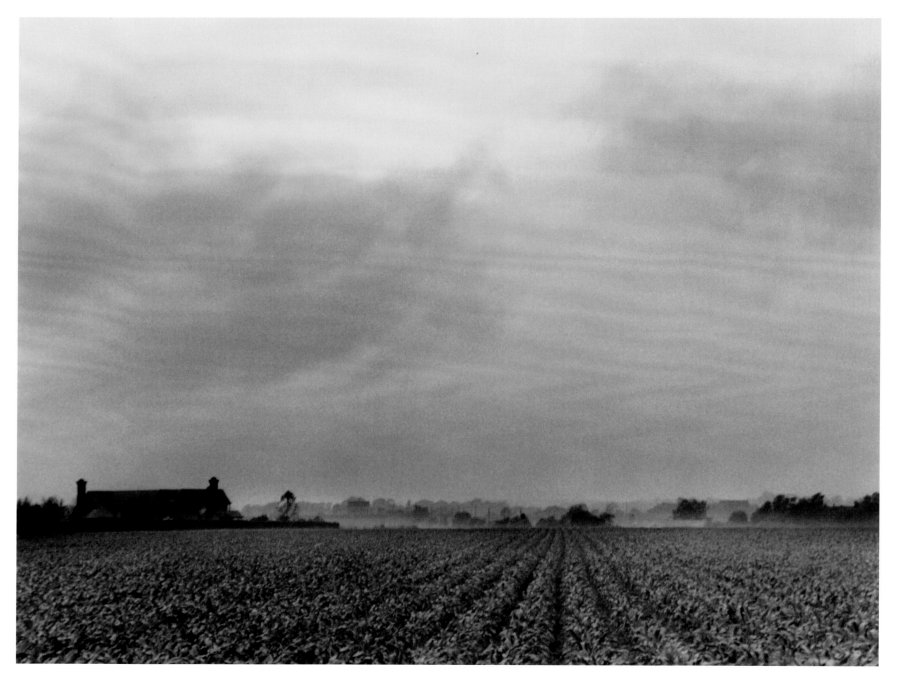

26. FIELD AND HOUSES AT DUSK, SAG MAIN STREET

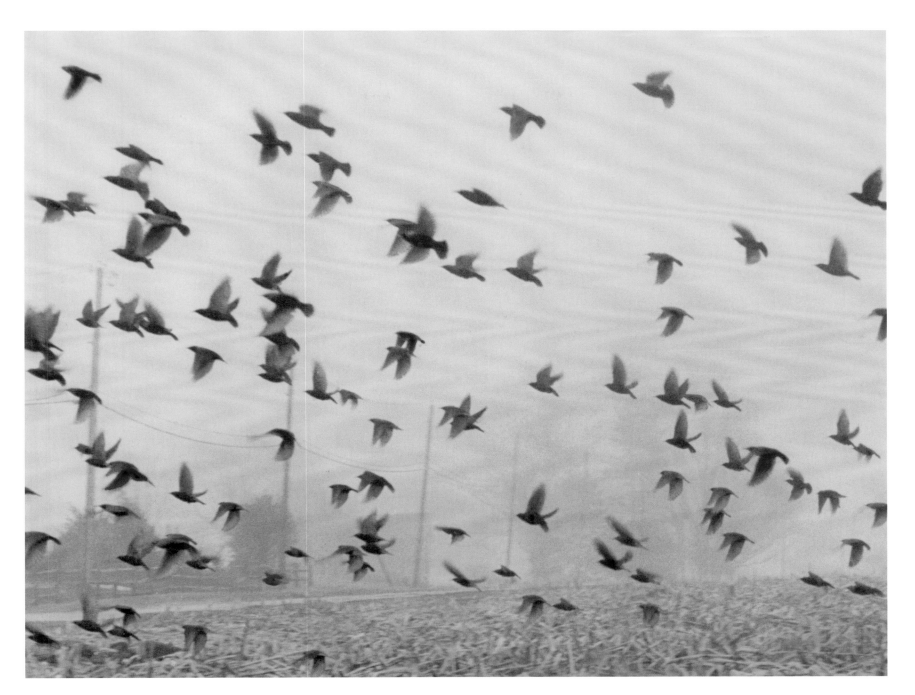

27. Harbingers

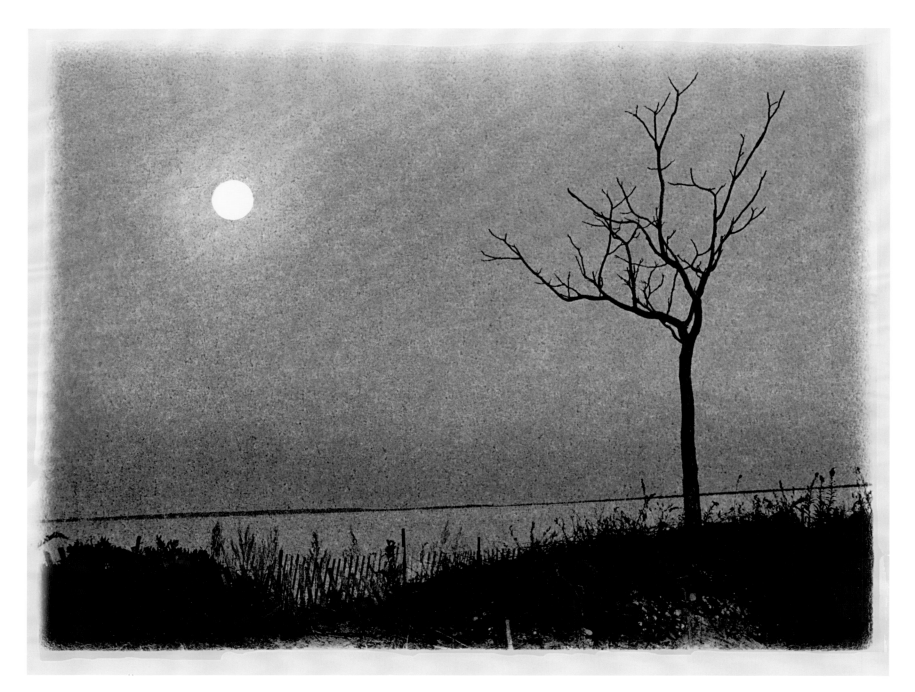

28. HUNTER'S MOON

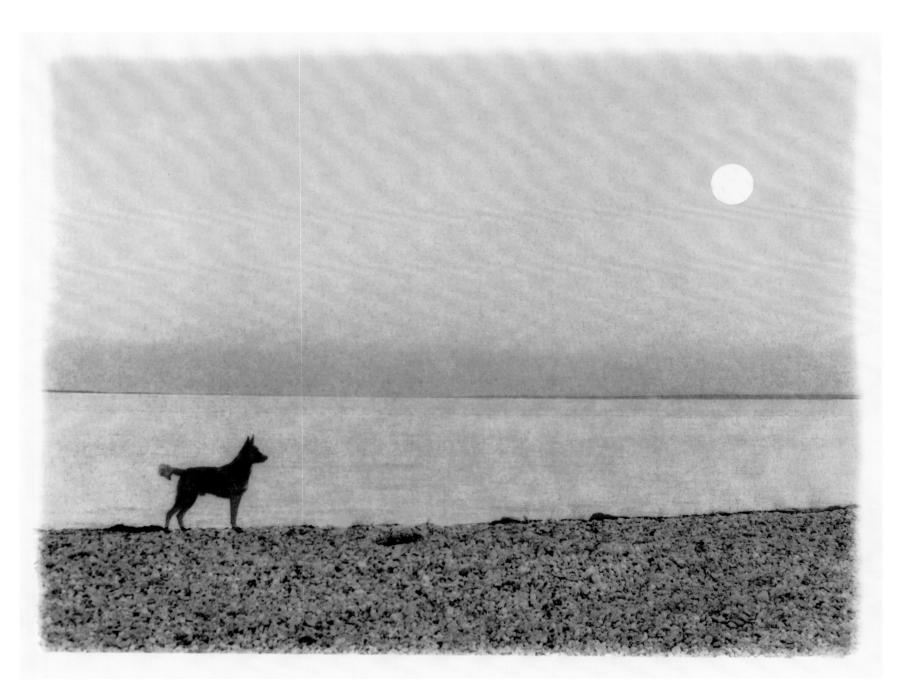

29. *Entre Chien et Loup*

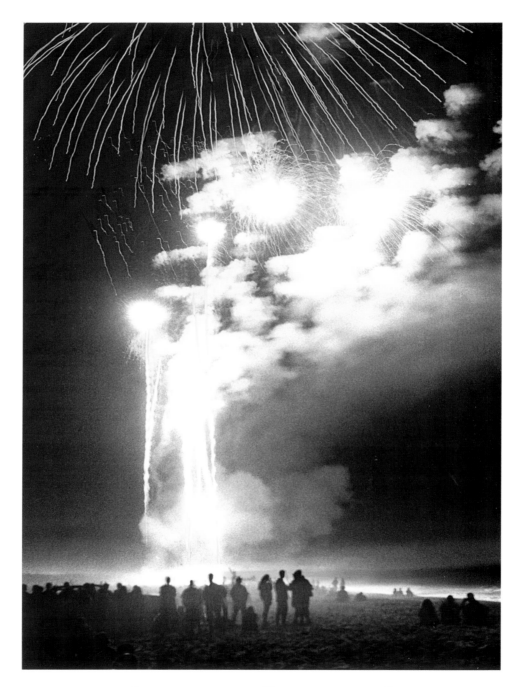

3 0 . F I R E W O R K S , F O U R T H O F J U L Y

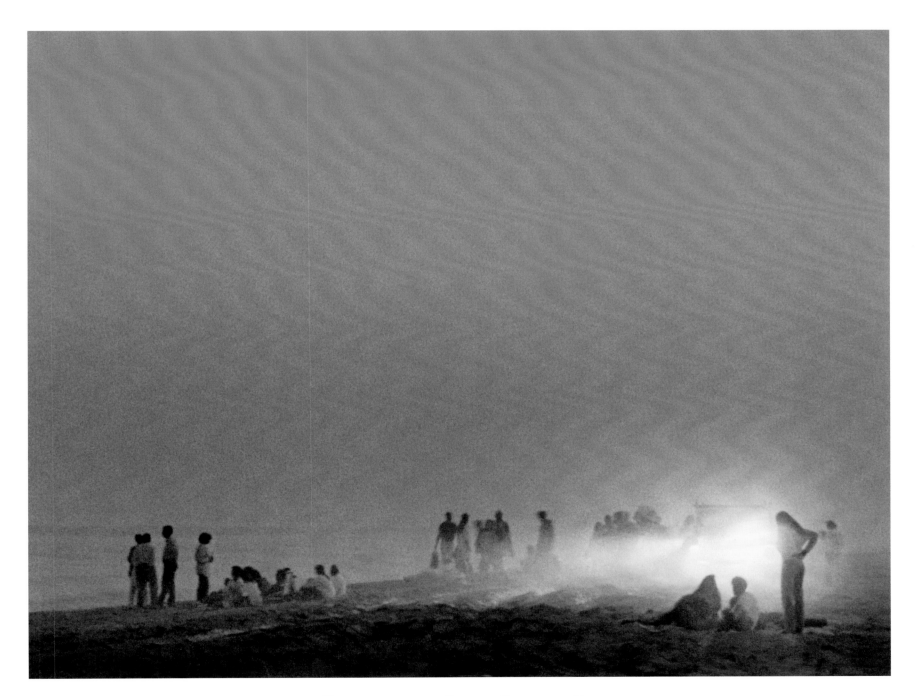

31. FOURTH OF JULY BEACH PARTY

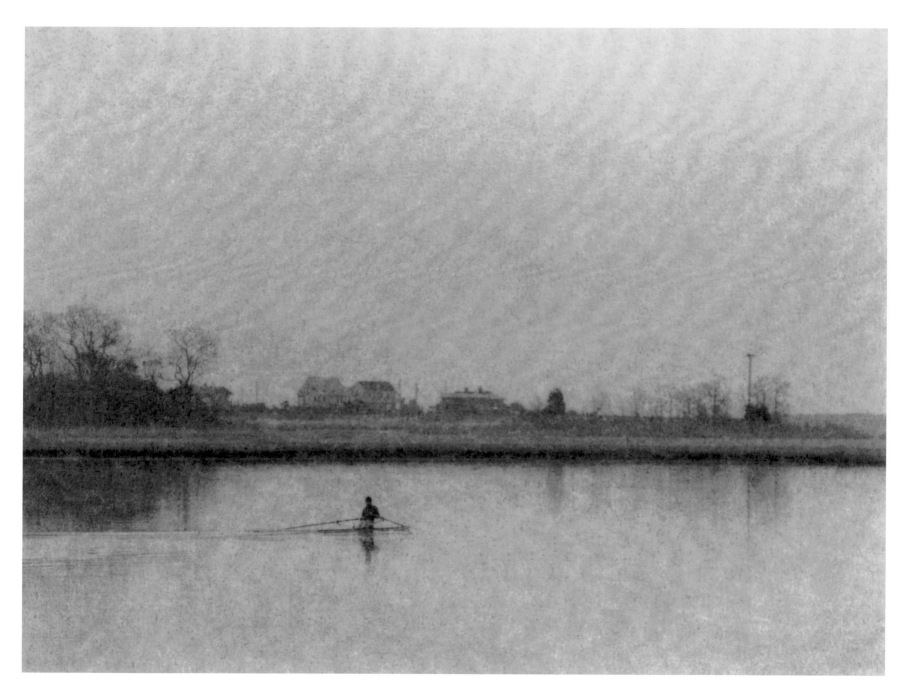

32. SCULLING, ACCABONAC

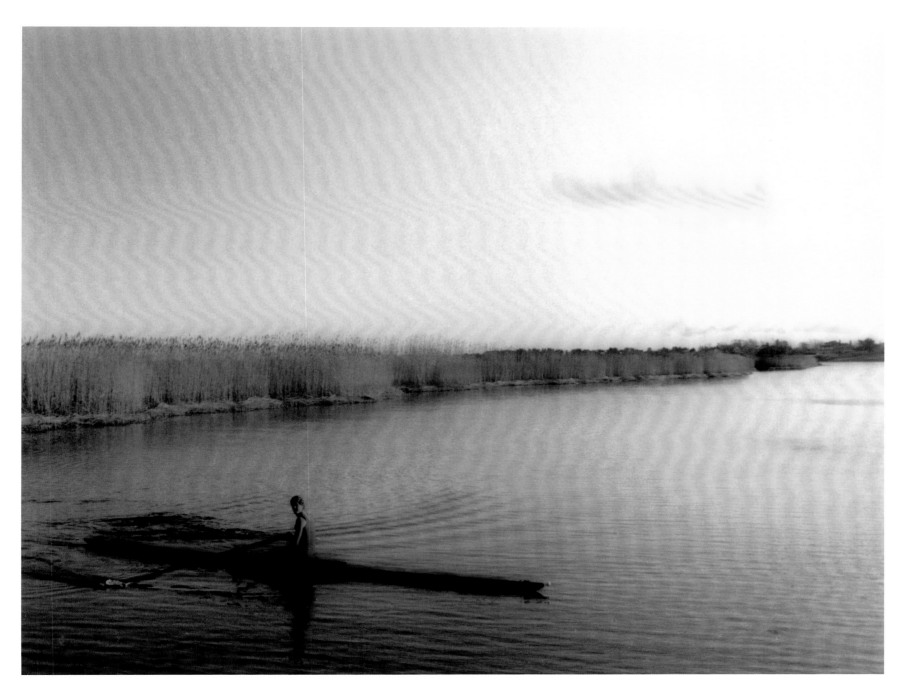

33. SCULLING, SAG POND

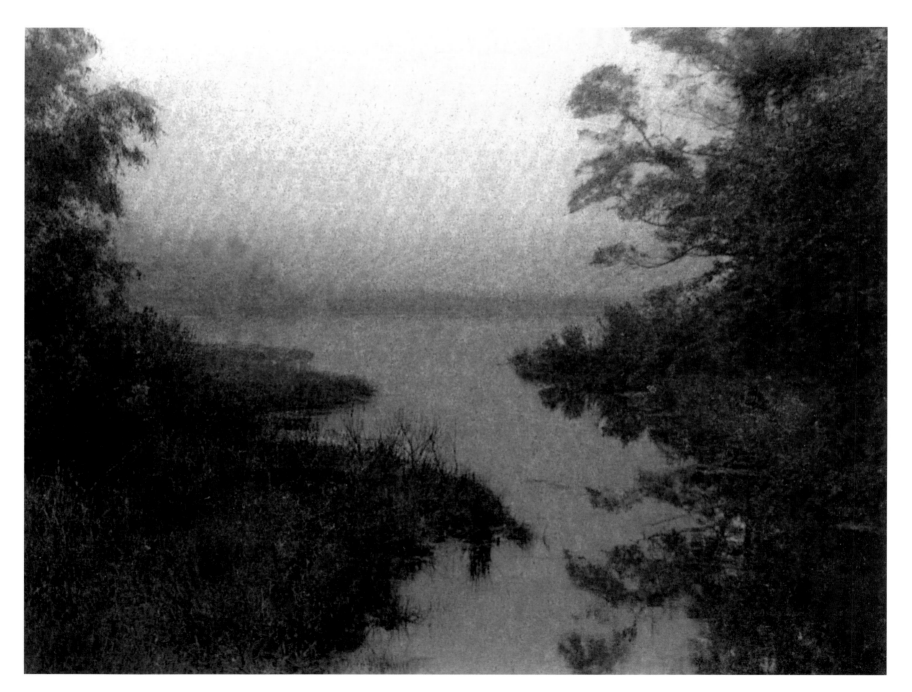

34. ACCABONAC HARBOR AND PUSSY'S CREEK

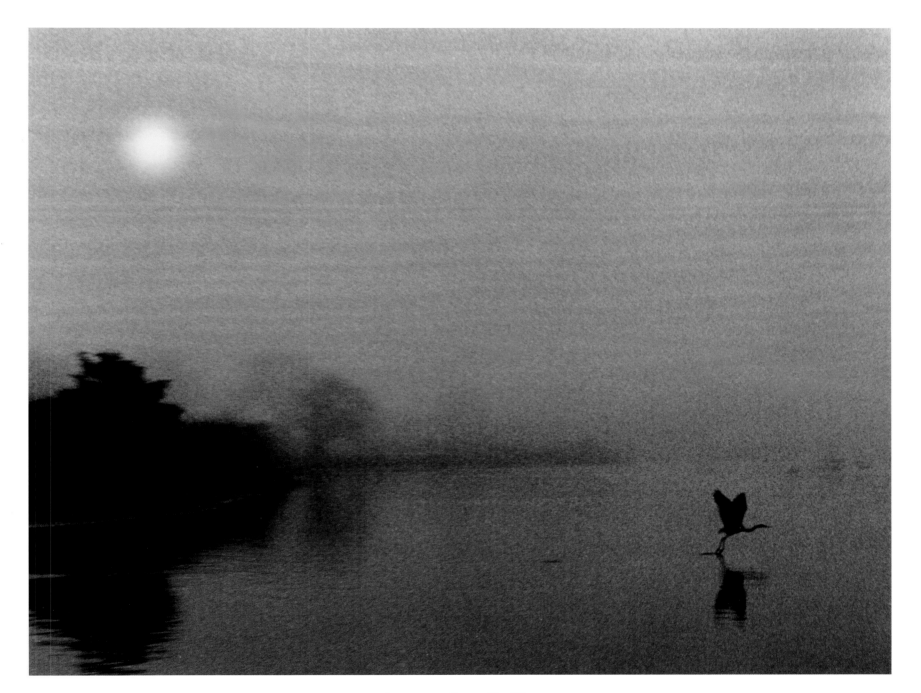

35. GREAT BLUE HERON

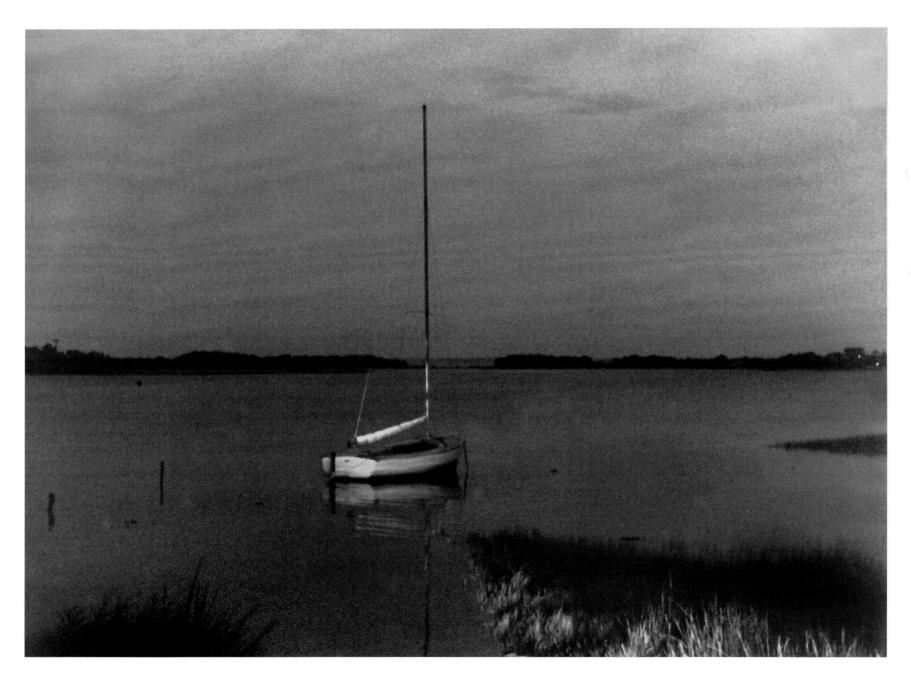

36. Yellow Sailboat

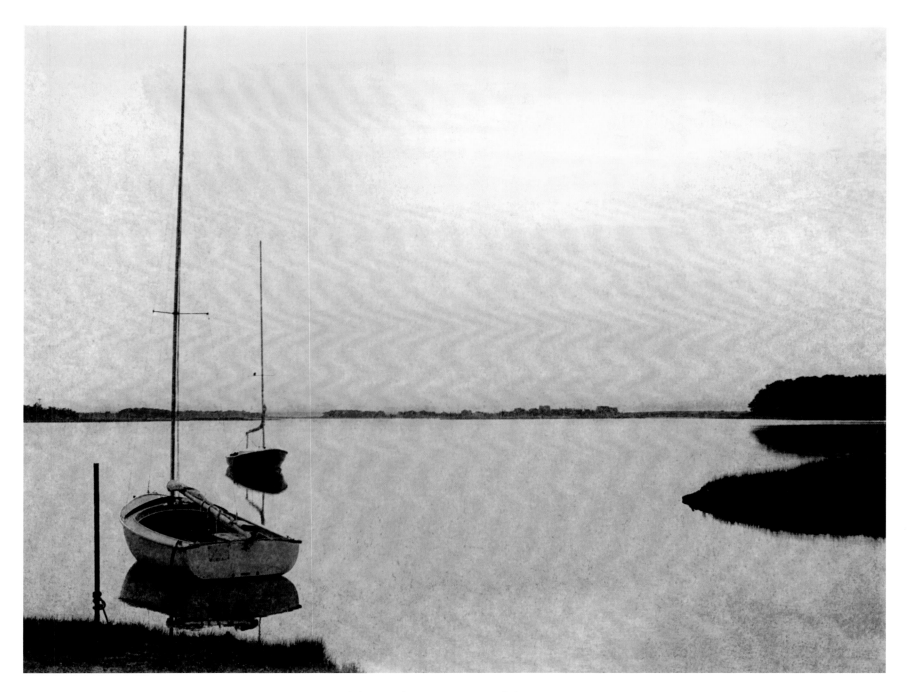

37. TWO BOATS AT MOORING

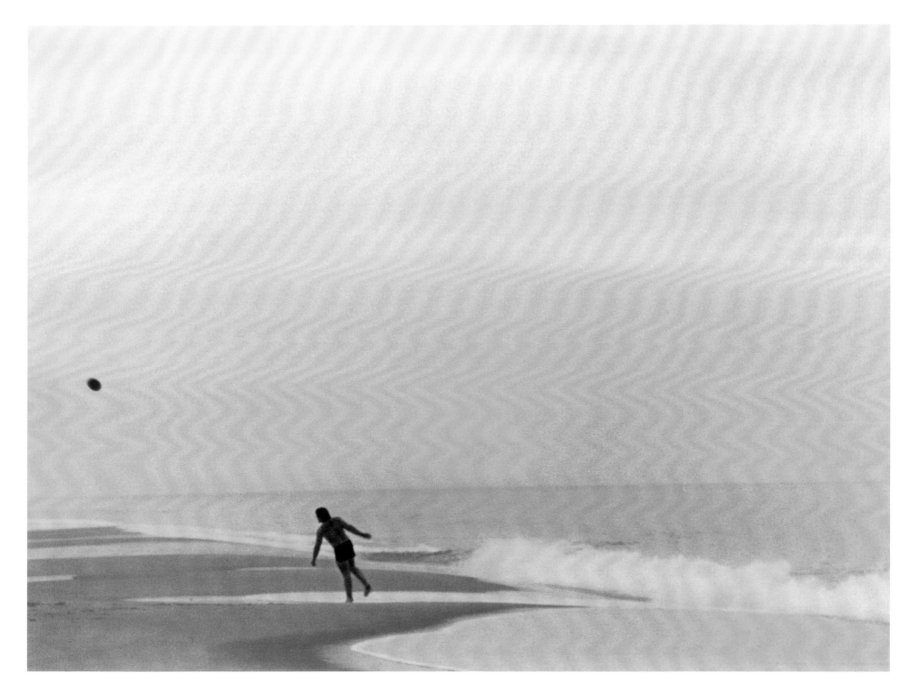

38. Frisbee Player

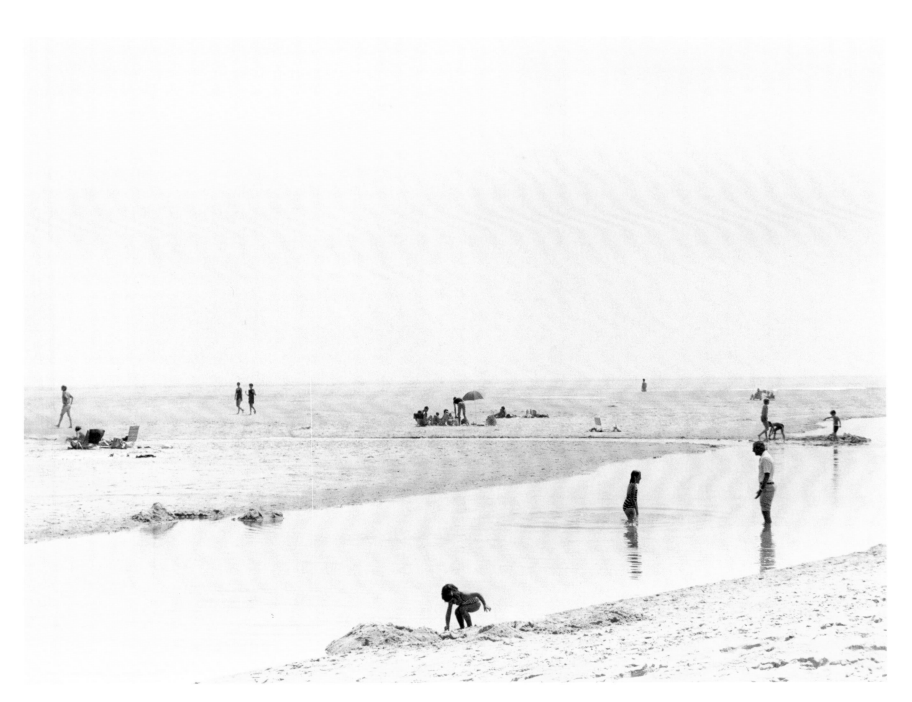

39. Beach Idyll

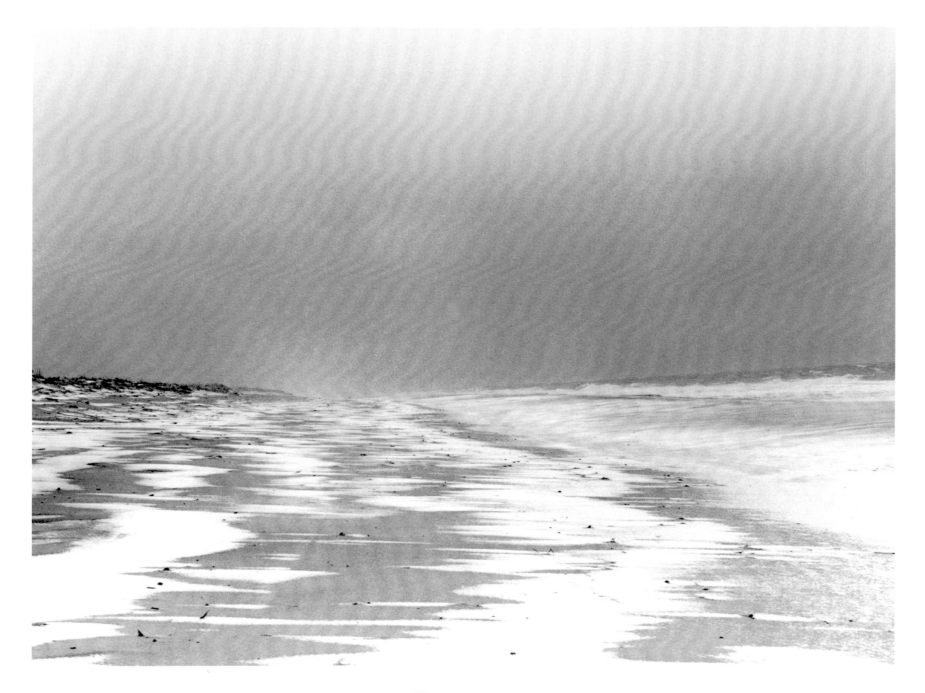

40. WINTER BEACH

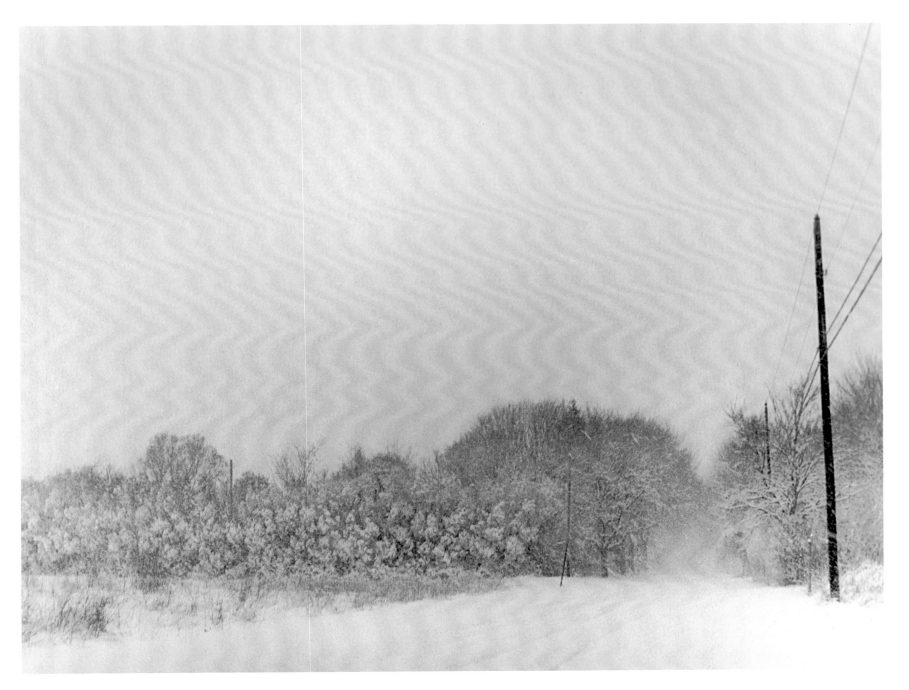

41. SNOW SCENE, SAG MAIN STREET

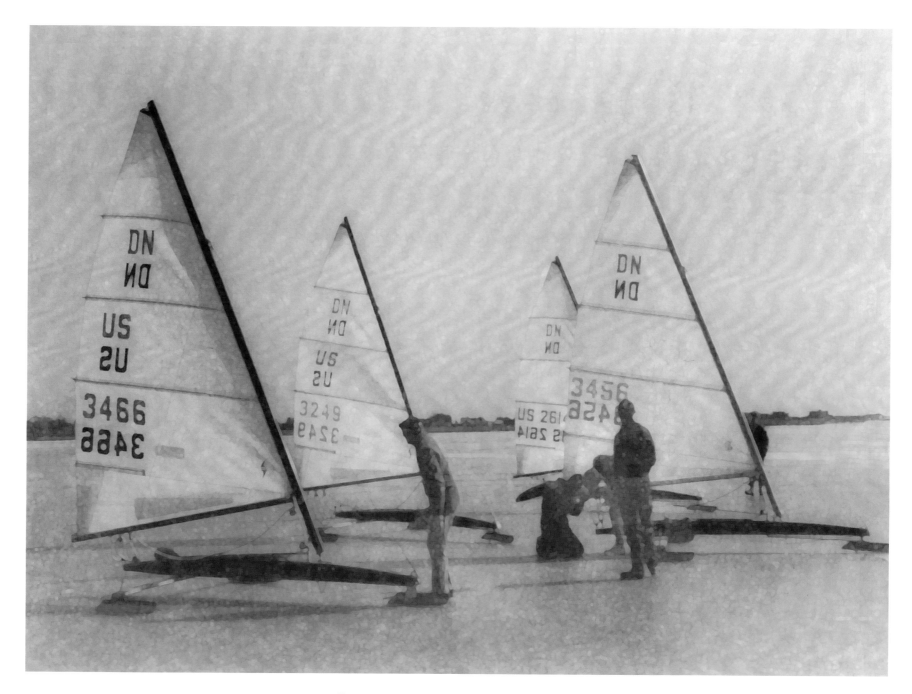

42. Iceboating at Sagg Pond

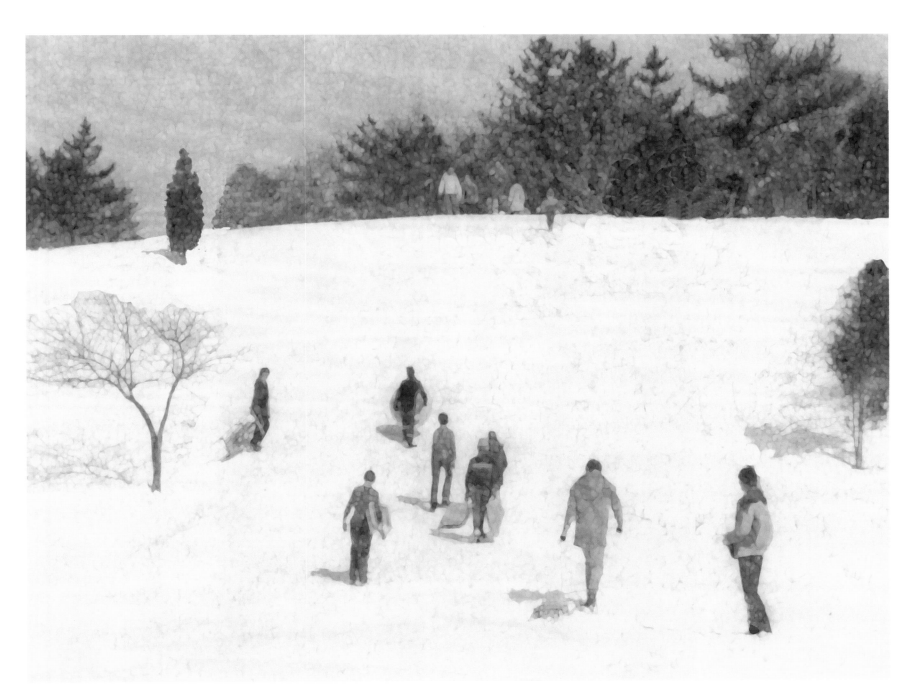

43. Sledding, Quail Hill

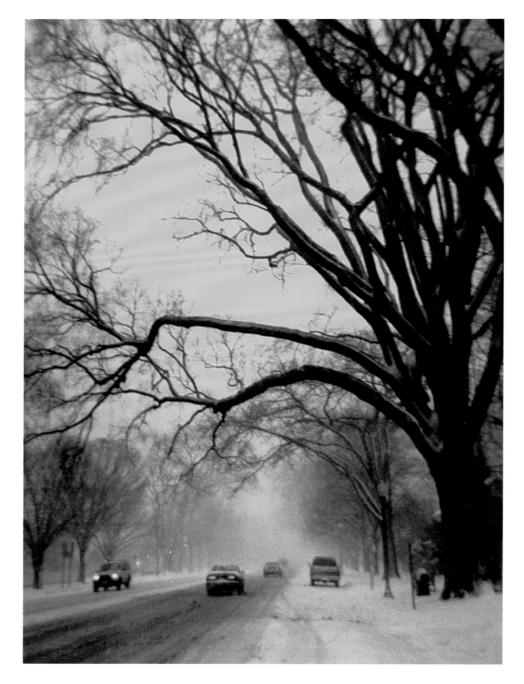

44. SNOW ON MAIN STREET

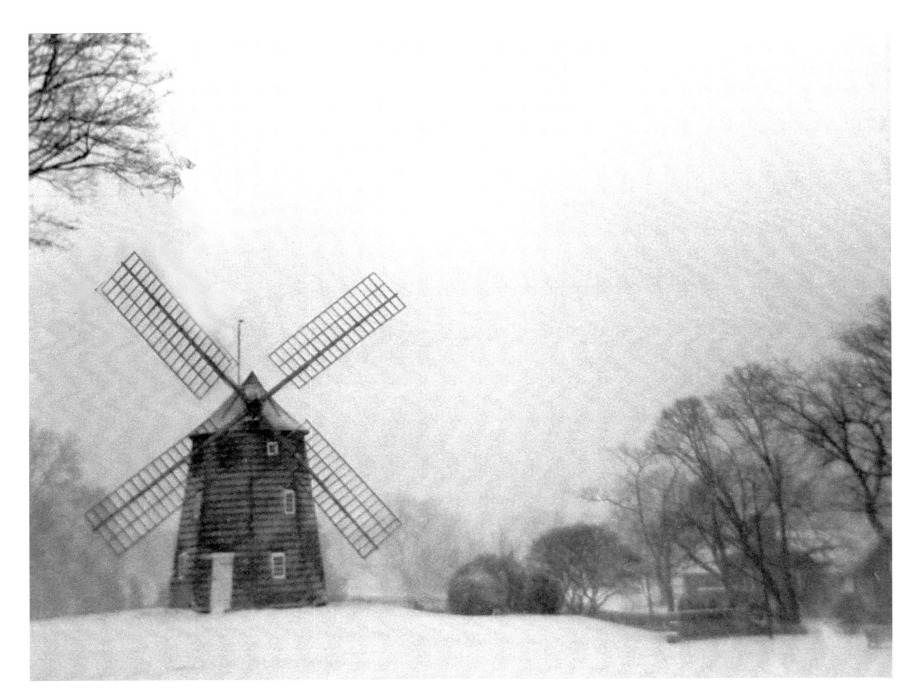

45. WINDMILL

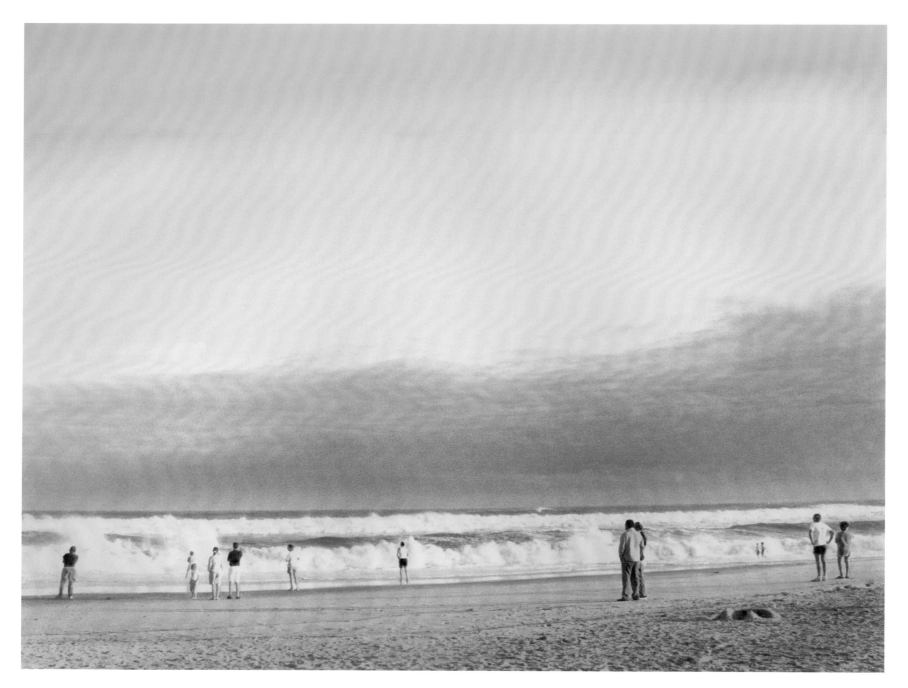

46. ON THE BEACH

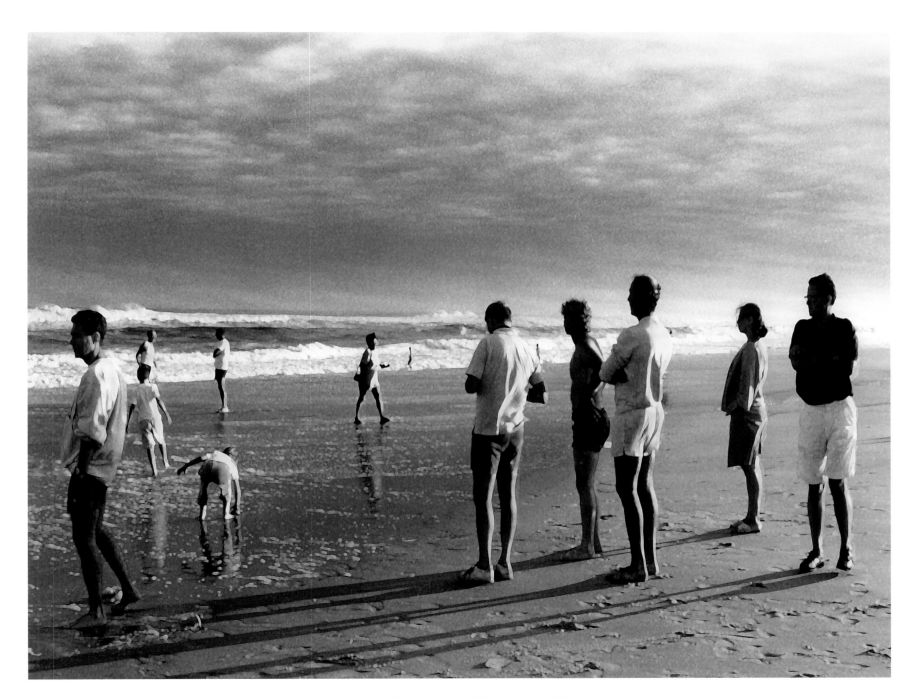

47. On the Beach II

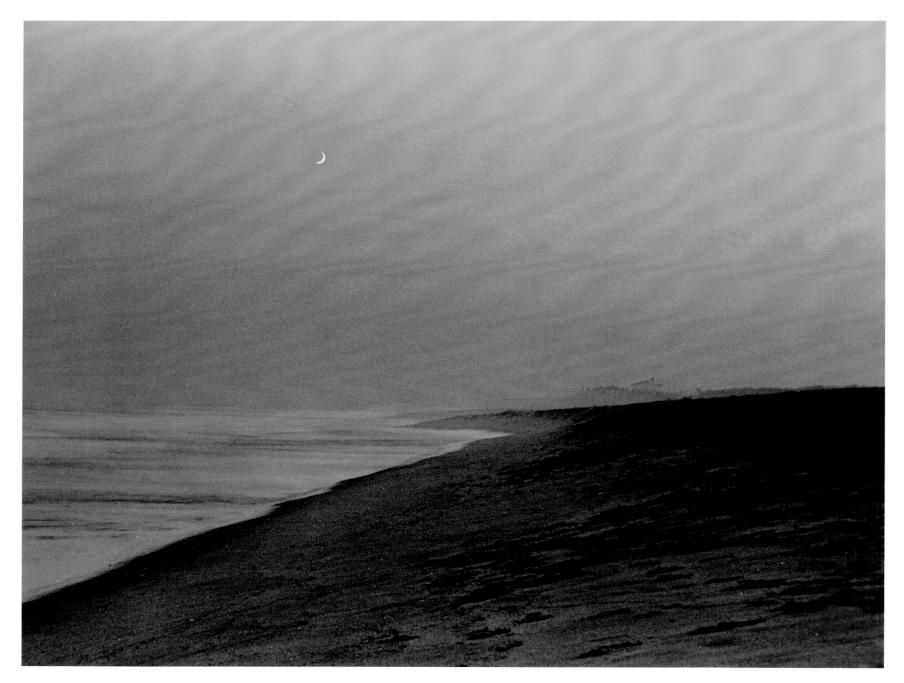

48. LATE EVENING, ATLANTIC BEACH

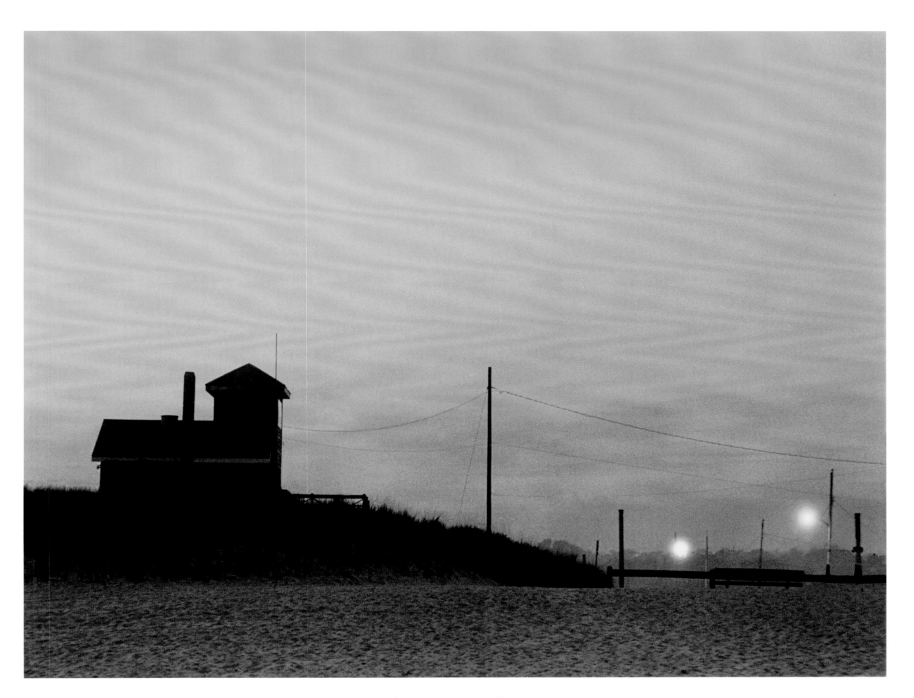

49. ATLANTIC BEACH

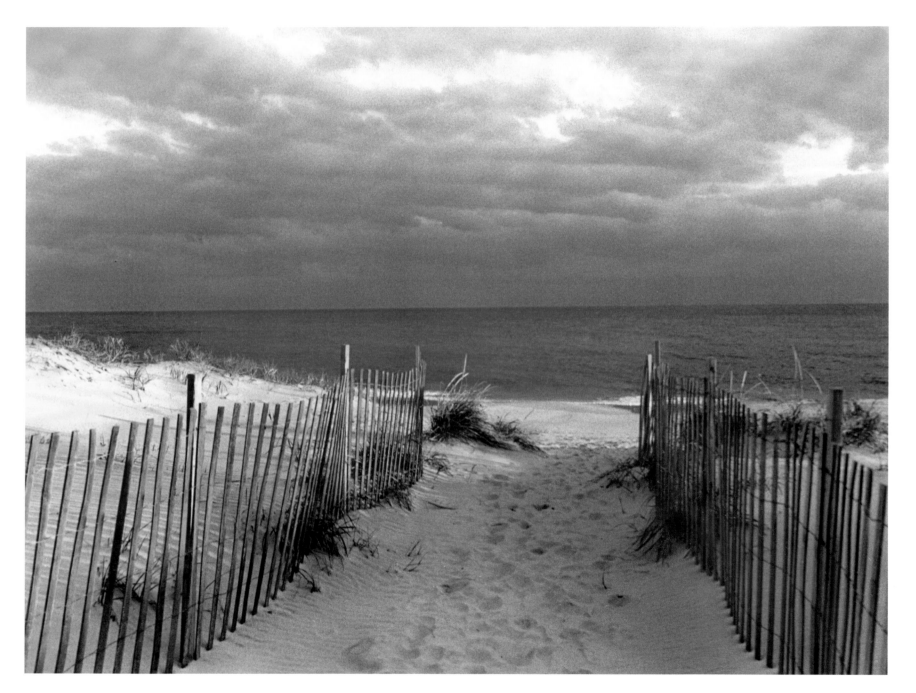

50. Sunlight and Dune Fence

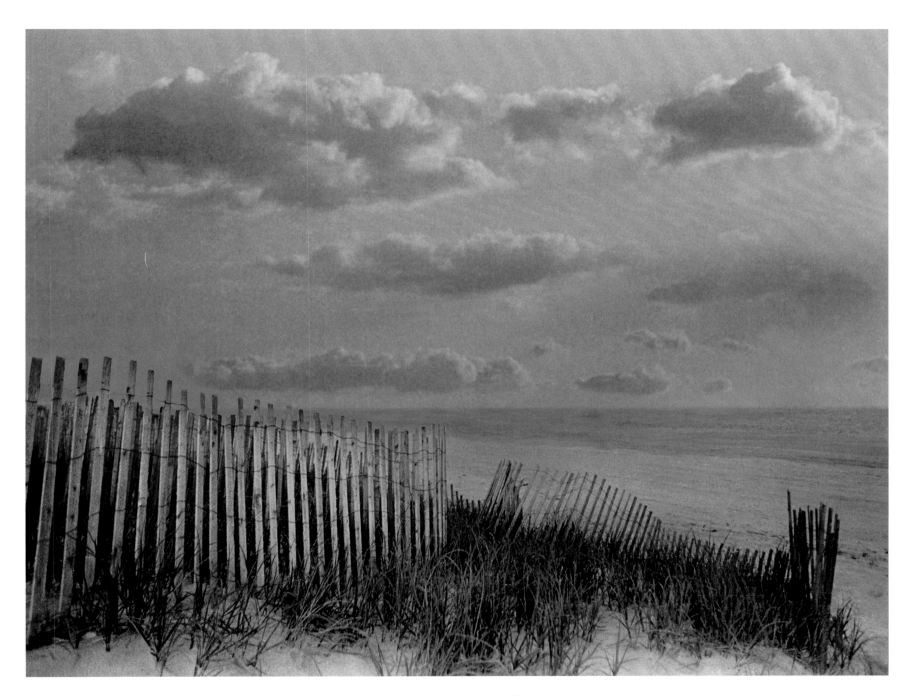

51. DUNE FENCE AT TWILIGHT

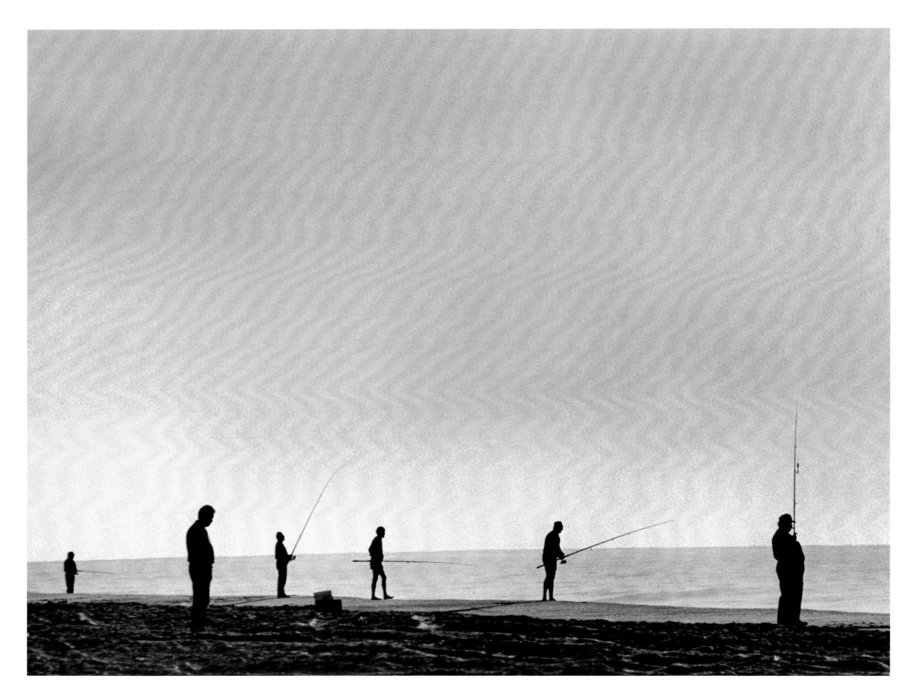

52. SURFCASTERS

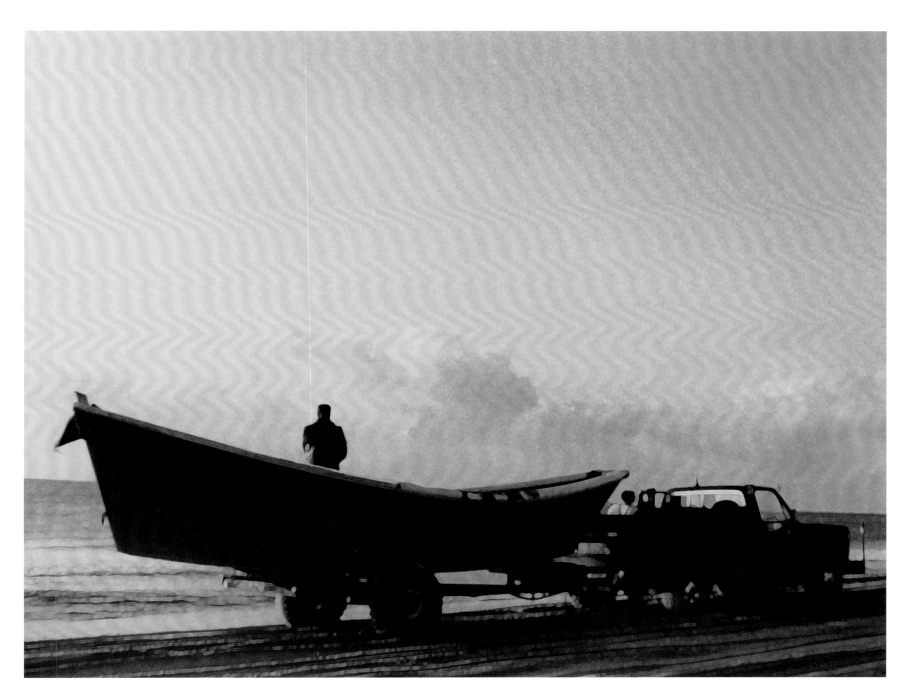

53. HAULSEINER

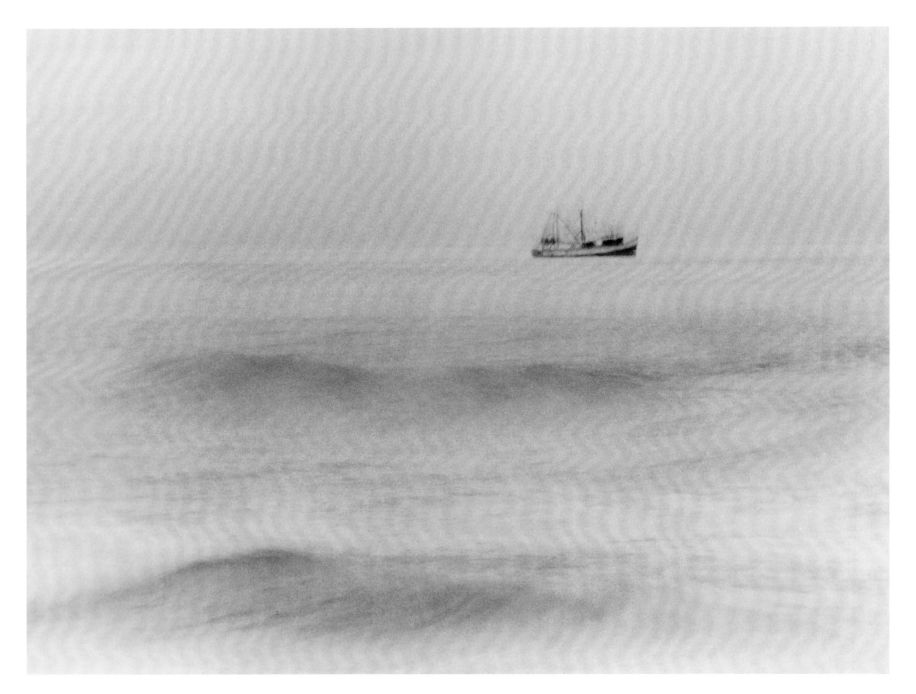

54. DRAGGER

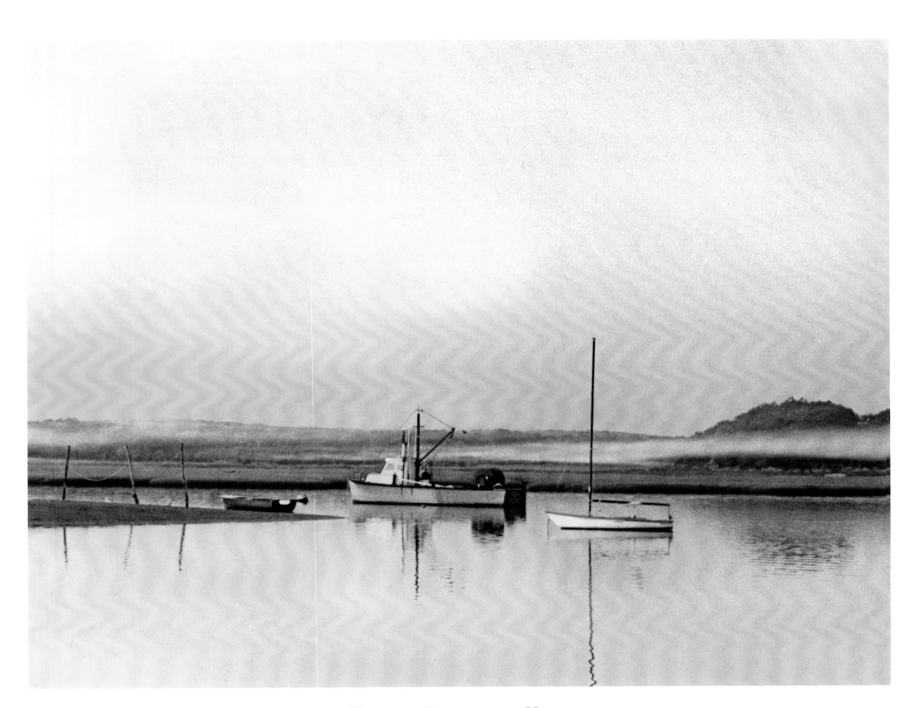

55. THREE BOATS AT HARBOR

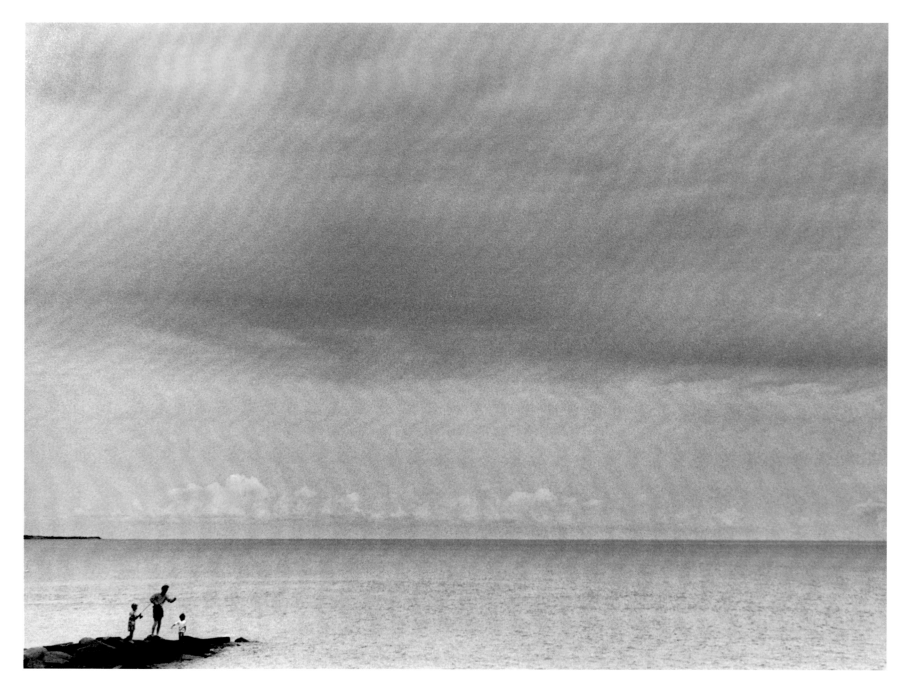

56. THREE FISHERMEN, GARDINERS BAY

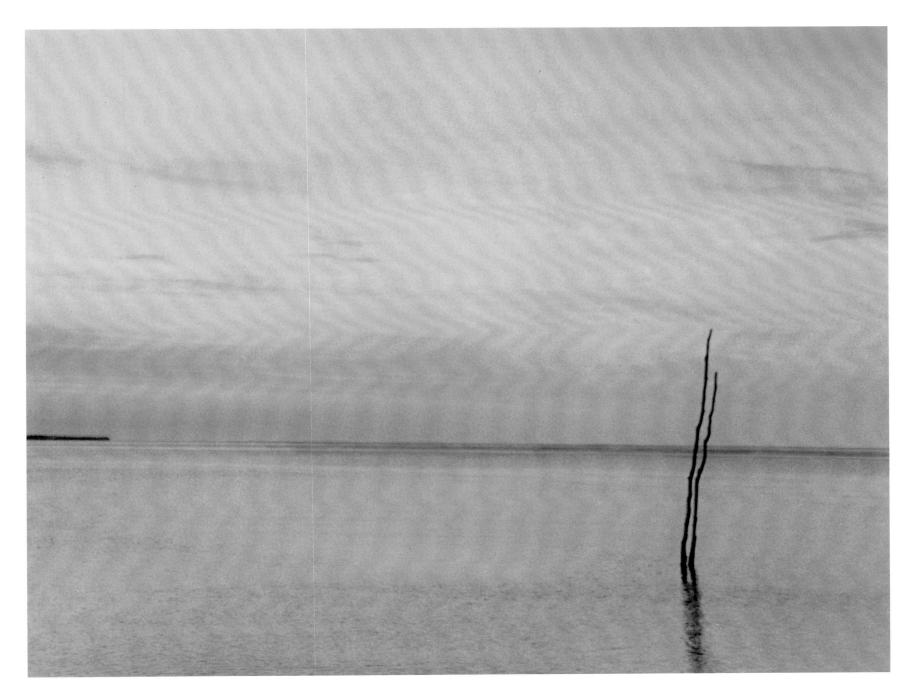

57. Gardiners Bay Near Fresh Pond

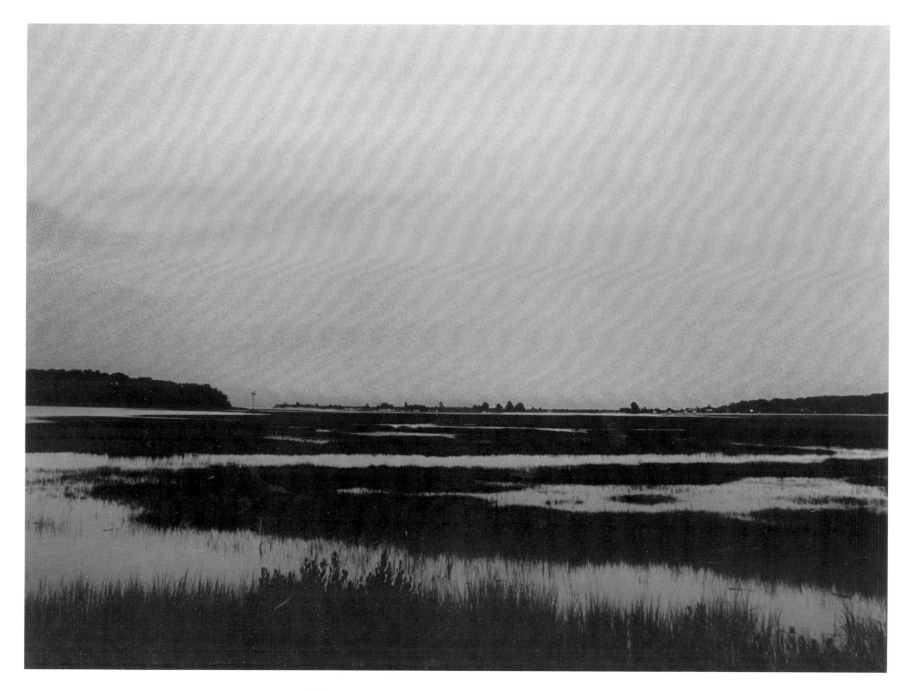

58. WETLANDS, ACCABONAC HARBOR

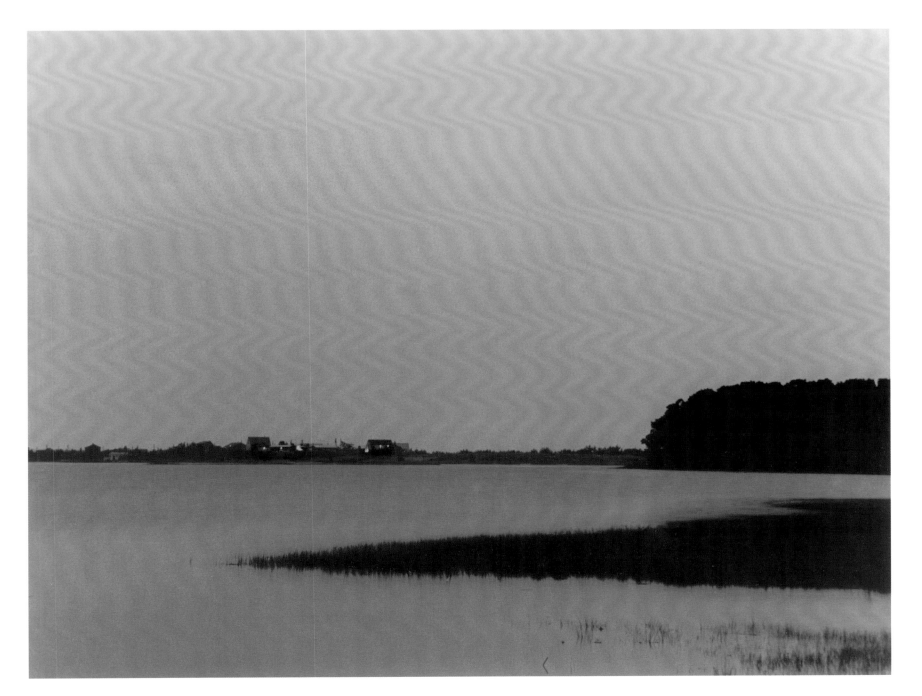

59. Lights Across the Harbor

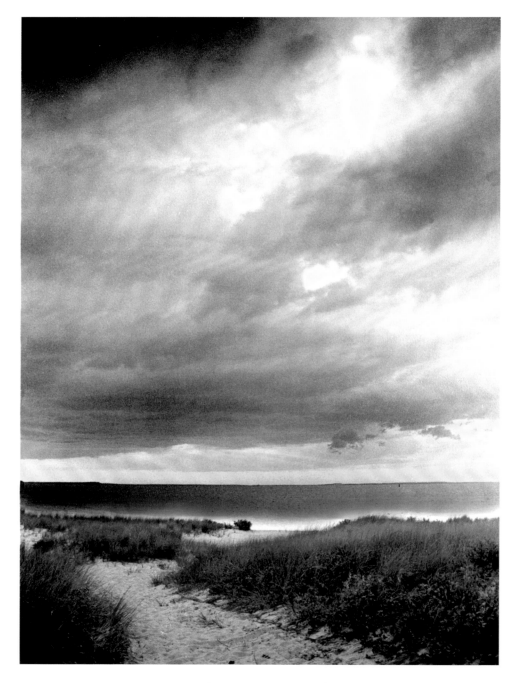

60. Constable Sky

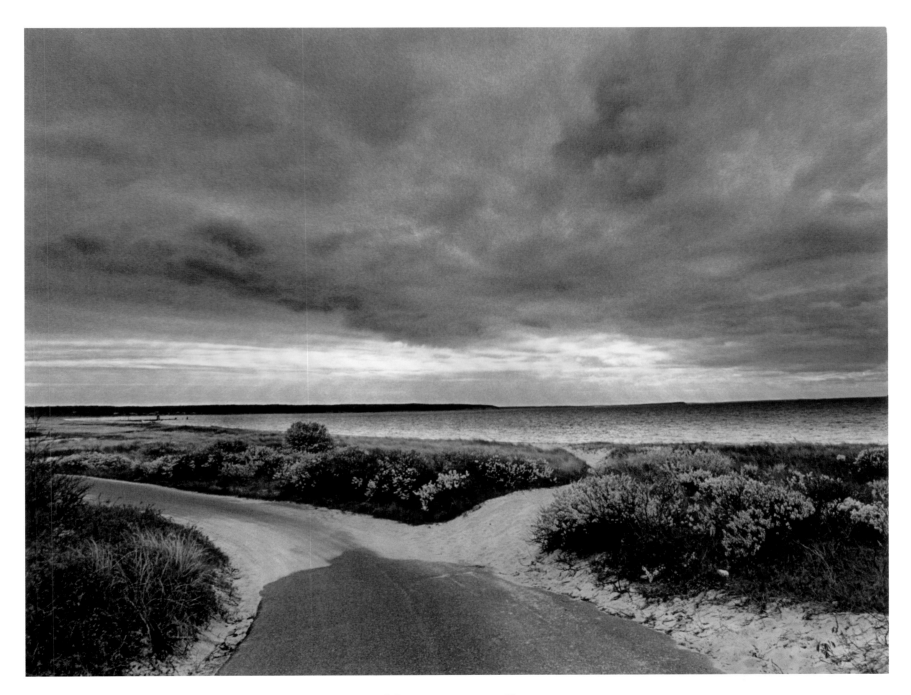

61. MAIDSTONE BEACH

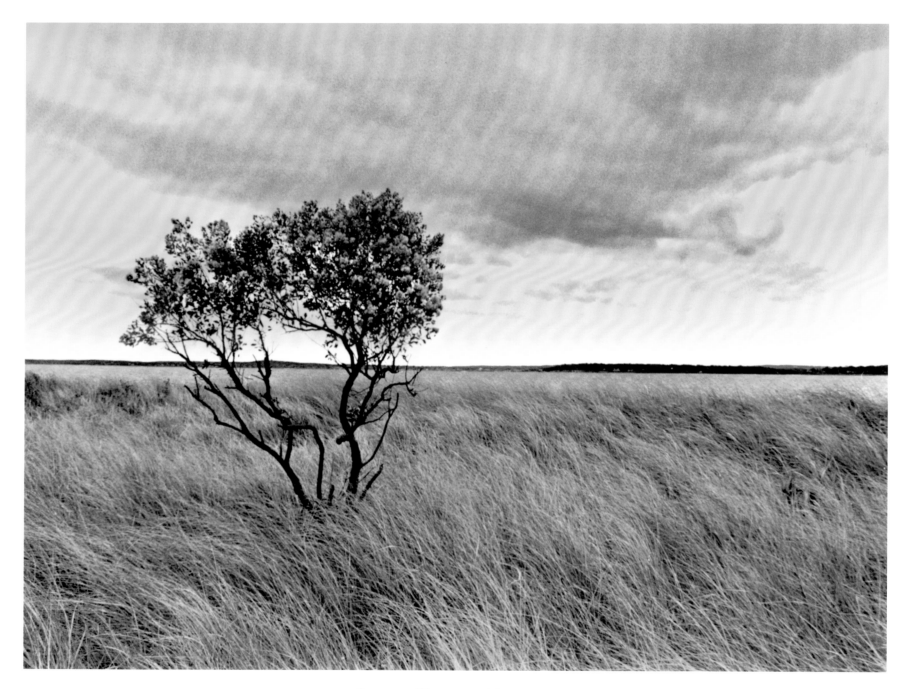

62. SHAD TREE, MASHOMAC

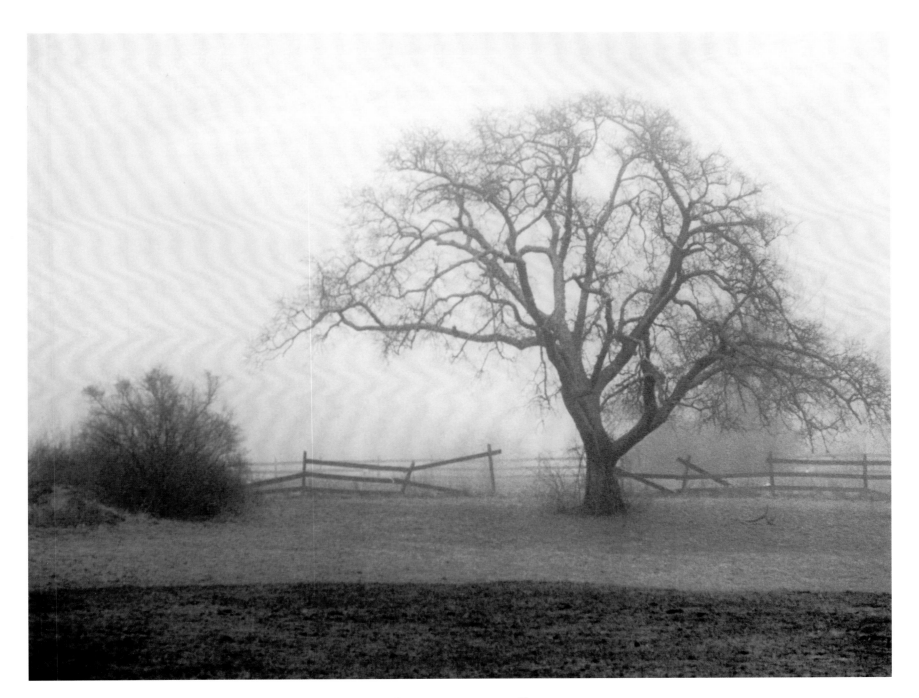

63. CRAGRAMAR FARM

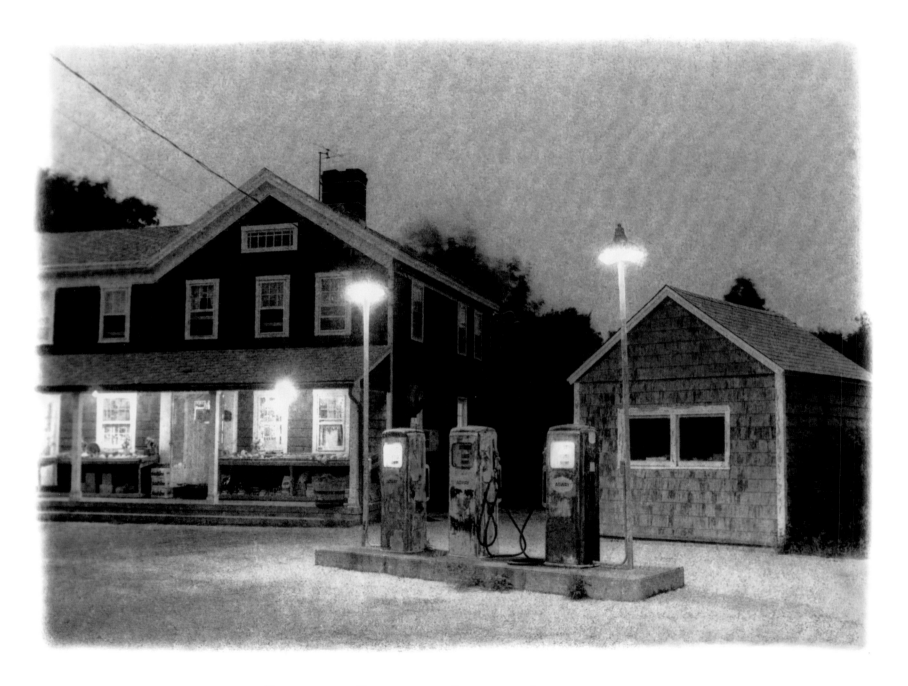

64. SPRINGS GENERAL STORE, SUMMER HOURS

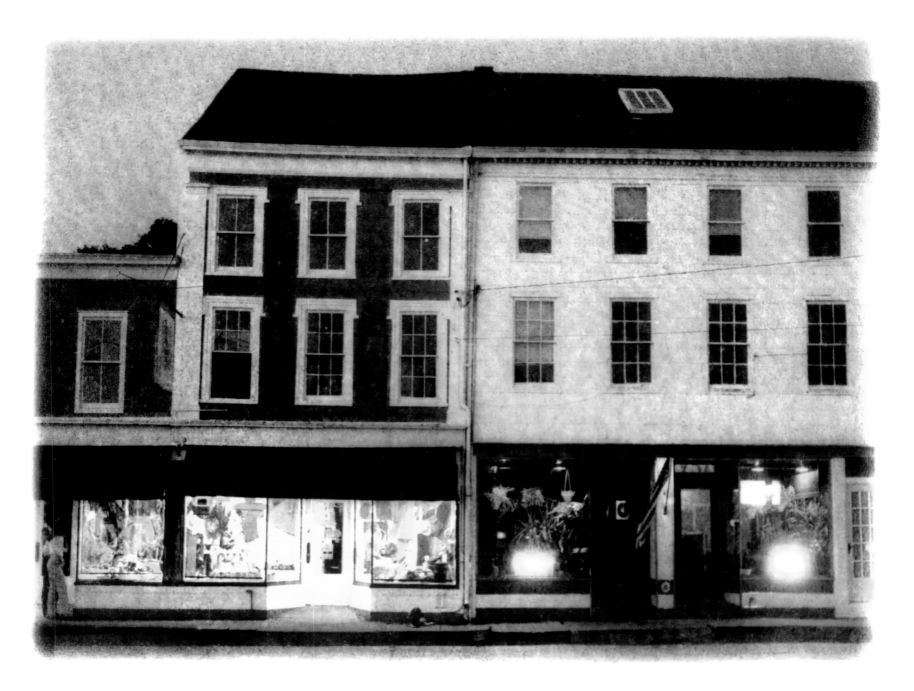

65. STOREFRONTS, SAG HARBOR

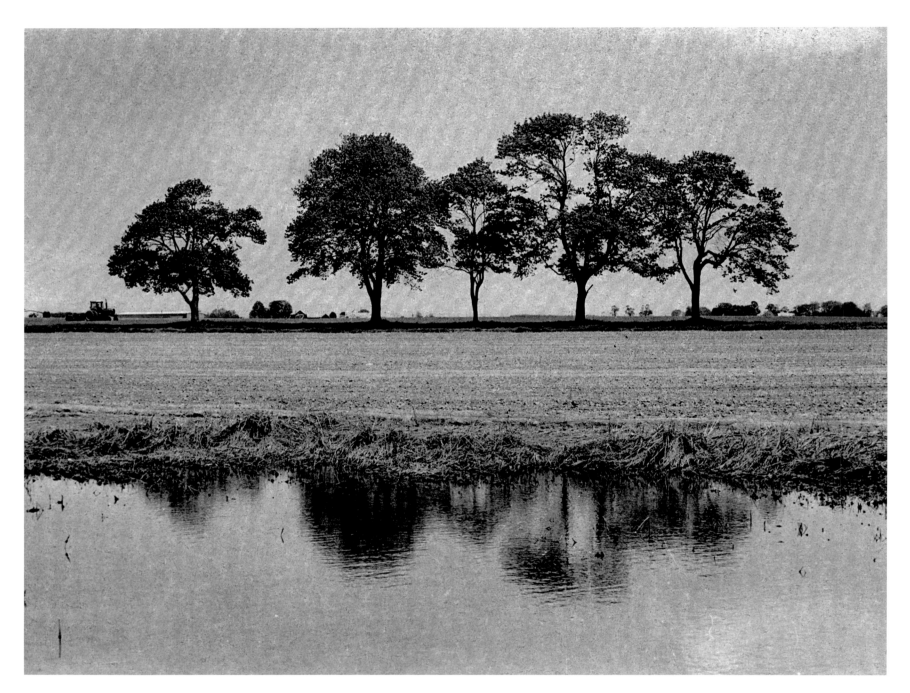

66. Five Trees, Sagaponack

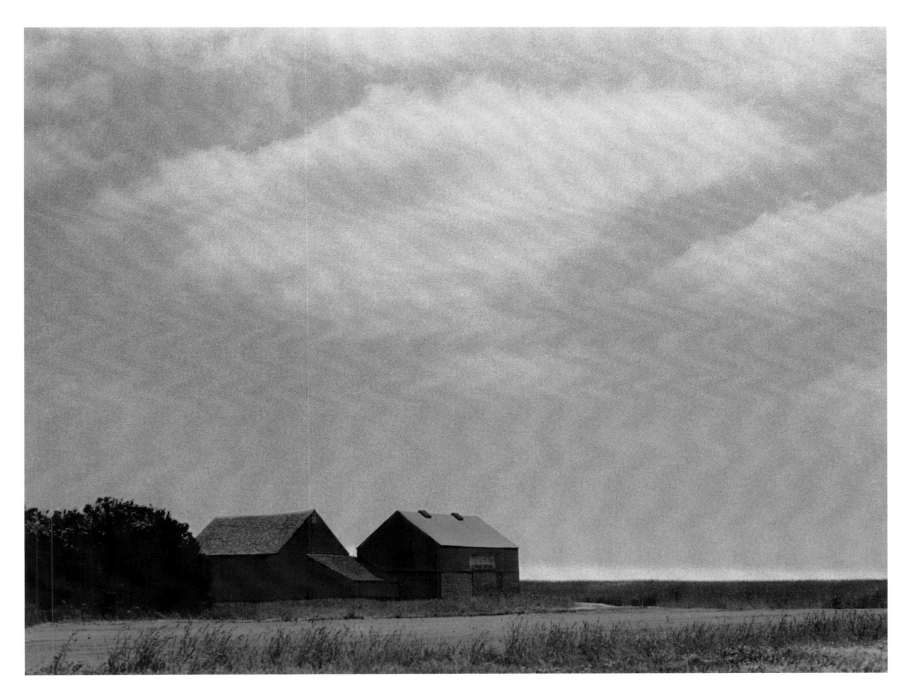

67. Barns, Watermill

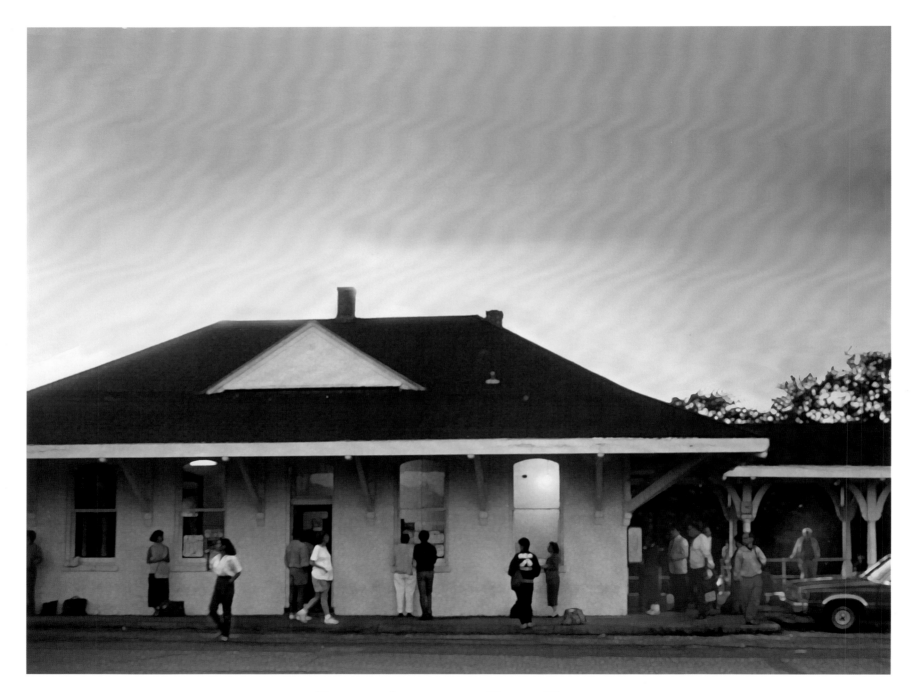

68. Train Station, East Hampton

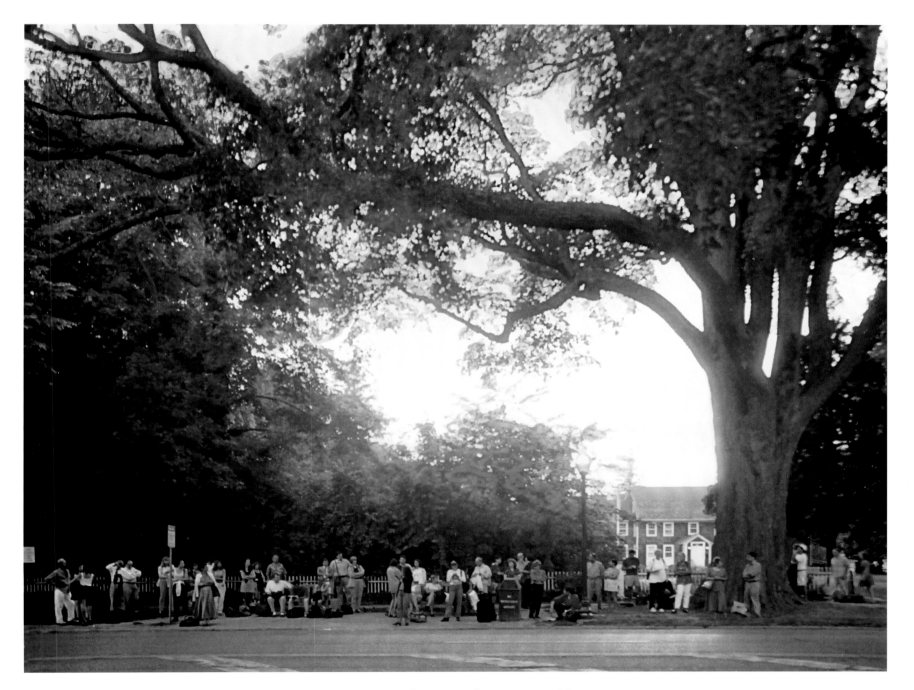

69. Jitney Stop, Sunday Night

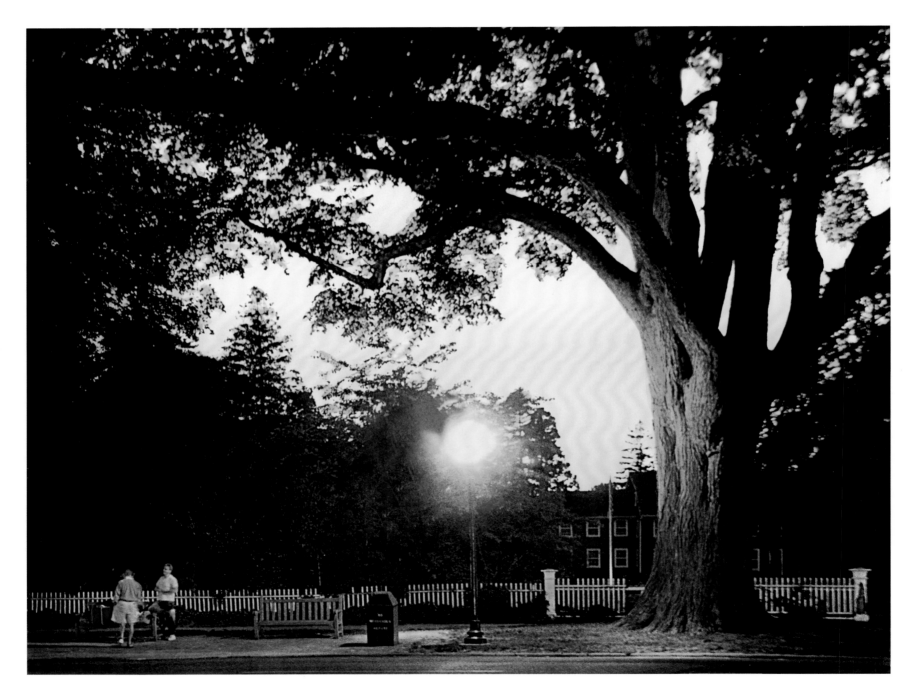

70. THE CONVERSATION